Drawing
The Personal View

An individual approach to drawing from
direct observation

Gerald Woods
With a Foreword by Roger de Grey PRA

GREENWOOD
PUBLISHING

Typeset in Monotype Garamond and
printed in Great Britain by
Jolly & Barber Limited, Hillmorton
Road, Rugby, Warwickshire

First published 1986 by
Greenwood Publishing,
The Tallet, Church Street,
Minehead, Somerset TA24 5 JX,
England

ISBN 0 946824 01 0
ISBN 0 946824 02 9 (pbk)

Drawing: The Personal View

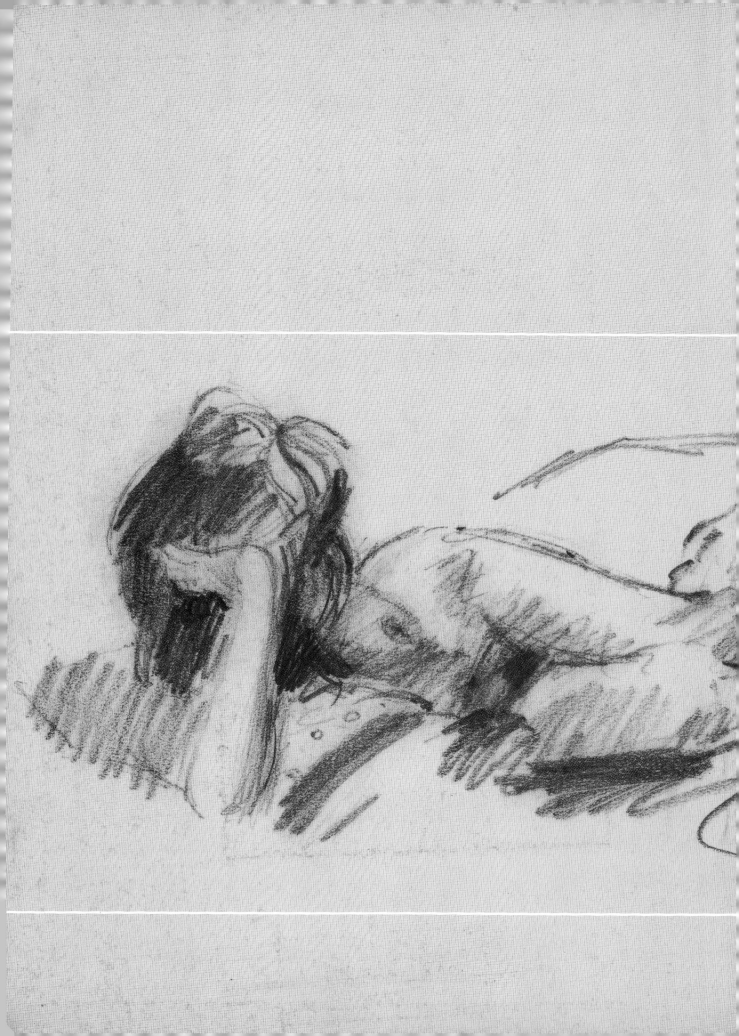

Contents*

*Where drawings reproduced are not the work of
the author, they are acknowledged to the
artist in the caption provided

ACKNOWLEDGEMENTS. For
assistance willingly given in the
preparation of this book I would like to
extend my thanks to Bruce Brown for
his valued encouragement throughout;
to John Henn who contacted various
artists on my behalf and helped in a
number of ways; to the widows of the
late Christopher Chamberlain and the late
Henry Inlander for allowing me to
reproduce their husband's work; to all
those artists who loaned their work for
reproduction; to Malcolm Ferguson and
his wife who kindly gave an assessment
of the drawings and read the manuscript
for my publisher; and finally to Jolly &
Barber Ltd for taking a keen interest in
the production of the book.

Foreword

There have, of course, been other books designed to assist us in our understanding of the multiple intentions of artists when they convey their sensations in line and tone before the complex compositions of the visual world. This book, however, differs from most others in that it presents the personal philosophy of a gifted and versatile artist, as well as rehearsing with perception and sensitivity the accumulated wisdom of someone imbued with the variousness and reactions of life in the studios of schools of art. Drawing widely from many sources to illustrate his theses, Gerald Woods matches example to text in a way that can only be done by someone personally concerned and profoundly learned in the history and practice of drawing. His observations, both visual and intellectual, will be of lasting value to both artists and enthusiasts alike.

Roger de Grey
President, Royal Academy of Arts

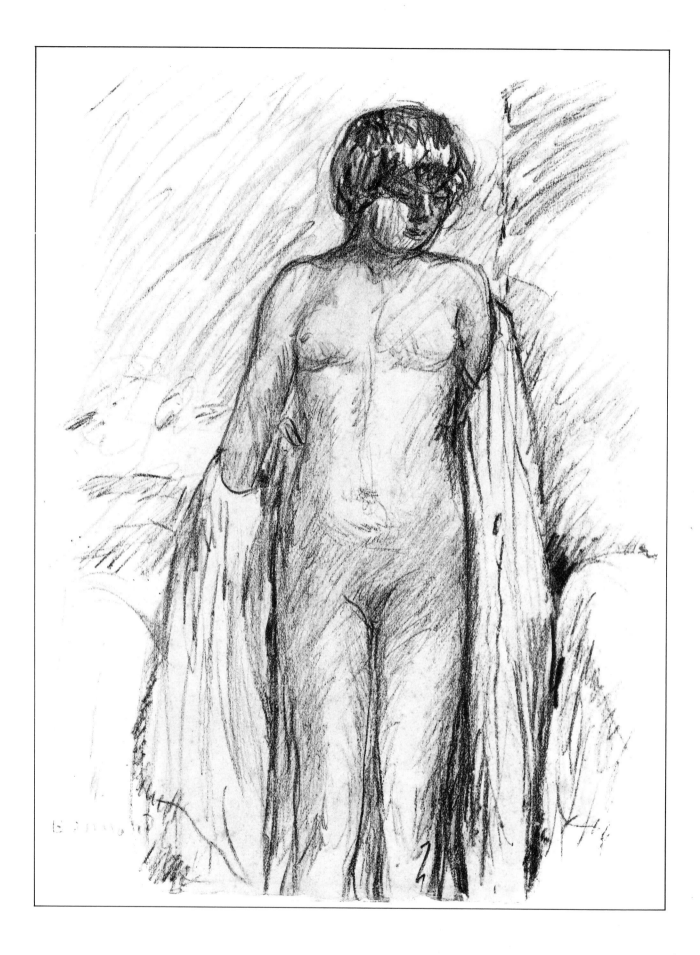

The Personal View

To know the world, we must construct it for ourselves.

DRAWING IS A WAY of finding out about the world we live in. To draw something is to gain a better understanding of the things we see, whether one is drawing an apple on a table or the exquisite proportions of a building designed by Palladio. It is my belief that someone who draws frequently from direct observation becomes more visually aware than someone who does not.

Drawing is the most direct, the most spontaneous medium available to the artist. The pencil becomes an extension of the hand through which the impulses of one's sensory experience is converted to marks which register what we have been able to confine to memory – for in that fragment of time between looking at the subject, and drawing what one sees, the memory plays an important part. The success or failure of a drawing may depend on just how much information one can retain in the mind, and when one talks about 'accuracy' in a drawing, one is concerned more with the degree of concentration that is evident in the work, rather than the attention given to detail.

The whole procedure of co-ordinating hand and eye was best demonstrated for me by a short clip of archive film of the painter Monet at work in his garden at Giverny. In this sequence the artist is seen in successive movements, tilting his head to one side to take in the subject before him, then with brush poised ready he puts marks down onto the canvas before the sensation fades. The problem of drawing is to find a way of working which allows us to observe things closely, and to put down what we see almost simultaneously. It is necessary to allow oneself to be governed by what one sees, rather than by any preconceived ideas about the kind of drawing one would like to produce. In the best drawings there is usually a sense of personal discovery; a sense of looking for, and finding, unexpected qualities, even in the most ordinary subject.

But drawing is not just about producing an authentic representation of things seen – one must also take account of the artist's emotional response to the subject he has drawn. There is an intimacy about most artists' work which exposes his thoughts, his mood, and his own shortcomings.

All artists working from direct observation are in a sense producing work which is autobiographical – most of their work has a distinctly recognisable quality. Yet many of the qualities which distinguish one person's work from another come from within the artist himself, even though he may be consciously striving to allow his drawing to develop

OPPOSITE:

Nude study/Lithograph
PIERRE BONNARD

from what he sees. Each has his own individual reason for making a drawing, and this determines the way it is made.

Bonnard said that to draw, the hand should glide over the paper as light as a shadow. To look at his drawings and at pages from his small sketchbook is to be able to share the artist's most intimate moments. Bonnard worked from direct observation incessantly – while walking in the country, in his own garden, in the bathroom, at breakfast and at dinner, responding rapidly to the slightest variation in anything that might arrest his attention. He used such a wide variety of marks that his drawings, though in monochrome, were capable of expressing colour. In his own diary he wrote, 'Drawing is sensation, colour is reasoning.' Most of Bonnard's paintings were in fact recreated from drawings, together with what information about the subject he was able to commit to memory. The almost overwhelming tenderness that he felt for his subject is somehow imprinted in the soft and delicate lines of his drawings. He was, to my mind, trying to produce drawings which impress not so much by their strength as by their very fragility.

Other artists prefer to exchange atmosphere for structure. The drawings of Cézanne for instance, appeal more to the intellect. His work has a kind of measured consideration which is almost entirely absent in the work of Bonnard, and yet both artists expressed essentially two-dimensional qualities in their work. Cézanne however, was concerned more with structural harmony and with producing drawings which verified the results of his extreme and intensive observation.

Drawing is a form of language, and when we look at a particular drawing we can trace the artist's progressive thoughts through a sequence of marks, the totality of which we recognise from our own experience of what a thing looks like. When however, the artist produces a drawing from an unusual viewpoint, or in circumstances to which we are unaccustomed, then much greater demands are made on us to understand what the artist is trying to describe. And just as the writer, or storyteller who tells everthing, is in danger of becoming a bore, so the artist who concerns himself with too much detail may miss the point of what exactly he is trying to communicate. I remember visiting an exhibition of contemporary prints at the British Museum a few years ago and among the many exhibits was an etching of a warship drawn in very fine detail. In a corner of the print the artist had signed his name and had additionally logged the number of hours spent on the drawing! The only message that this image conveyed to me was that the poor man had laboured many hours to produce something that was completely lifeless.

Delacroix said 'Sacrifice is a great art unknown to novices. They want to show everything.' To record something with complete accuracy is impossible – there is simply too much to cope with in terms of form and structure, light and tone, and in the infinite complexity of everything we see. The draughtsman is hampered by the limited range of his graphic vocabulary. He must therefore become increasingly selective in attempting to render a satisfactory account of what he sees, with economy of expression. Drawings by Rembrandt for example, flow from beginning to end with one sustained impulse. His work gives no hint of reconsideration or tentative revision – the drawings possess an authority which is decisive. There is a timeless quality about such drawings which make them as relevant today as they were in the 17th century. He was able to work from direct observation with a degree of unsentimental detachment, while at the same time managing to suggest in his drawings something of the inner nature of his subject. Rembrandt used strong tonal contrasts not just to suggest form and modelling, but to give a heightened sense of drama to his compositions, and to relate the figure to its surroundings. In this respect his work differed from the academic tradition of separating the figure from its background.

The poet Paul Valery said that most people stop at the first stages of the development of their thoughts. Even some of the best draughtsmen have talked about their work as being 'unfinished'. Cézanne for instance, after Vollard had posed for him a hundred times, felt unable to take the portrait anywhere near completion, though he reluctantly admitted that his rendering of the shirt was not too bad! Alberto Giacometti said that the more one works on a picture, the more impossible it is to finish it. Few contemporary draughtsmen have worked with the intensity of Giacometti – he felt that everything had to come through drawing, but often in despair and anguish said that it was an impossible task to render what the eye sees. He usually began his drawing of the model by concentrating on the eyes – 'If I could render a single eye correctly' he said, 'I would have the head, the figure, the world.' For Giacometti each drawing was a step towards the next – he was interested more in the possibilities of structure than with trying to uncover the personality of his sitter.

In the western world drawing is often seen as an activity that is preparatory to painting. In Giacometti's paintings however, there is no such separation. His paintings *are* drawings; the canvas is merely the most suitable ground for the constant reworking of the drawing which is characteristic of his method. When one is working intensely from observation, things no longer appear to be static – they are seemingly in

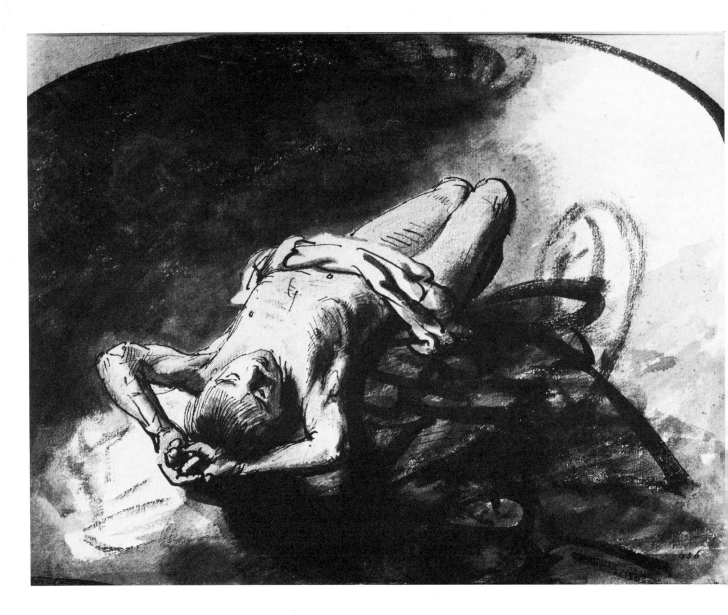

Recumbent figure of a youth/Pen and wash

REMBRANDT
(By courtesy of the Board of Trustees
of the Victoria and Albert Museum)

constant movement. The harder one tries to pin things down, the more difficult it becomes. 'The contour escapes me' Cézanne complained – and that is why his drawings have tentative, sometimes multiple contours which suggest vibrancy. His method of working allowed for constant movement at the edges of things.

The quality of line is critical in drawing; a single contour line applied with even pressure would simply reduce any delineation of a subject to pure pattern. The artist working from an exploratory standpoint is finding his way by using lines which respond to his feelings about the quality of light, the sense of form, and the relationship of one thing to another. To do this, subtle but perceptible gradations of tone and pressure are applied to produce a contour which is lost and found. Where for example, the light touches the edge of the form, the contour is barely stated and sometimes left out altogether. On the other hand, where there is a need for tonal emphasis, greater pressure is exerted. That is why artists such as Bonnard had a predilection for using very soft pencils or black crayon, and Giacometti preferred a harder point – much depends on what you are trying to achieve, and which qualities about a subject are the most important. Every artist has to discover by trial and error the most suitable

DRAWING: THE PERSONAL VIEW

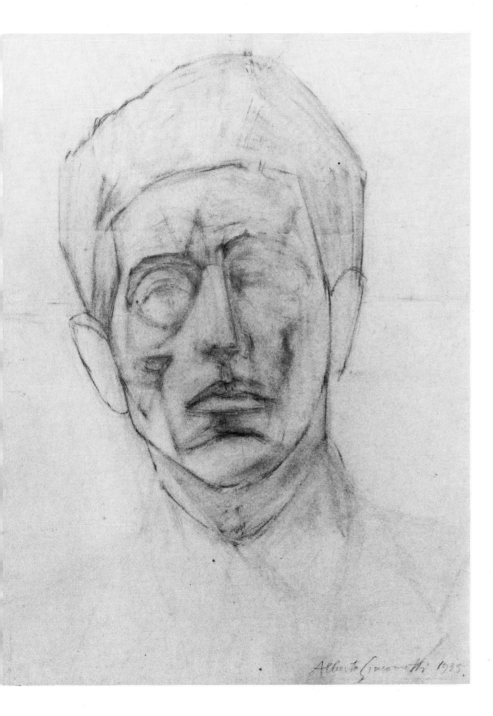

Self-portrait/Pencil
ALBERTO GIACOMETTI
(By courtesy of the Robert and Lisa
Sainsbury Collection, University of
East Anglia)

materials which best allow him to express his ideas. Initially it doesn't make much difference when one is simply trying to cope with the basic problems of proportions and learning to co-ordinate hand and eye, but eventually through experience one will find that a particular medium may be more suitable for one's own needs than another. The scale of the drawing is also something that can only be determined by personal experience. The choice of medium, and the conditions under which one is working will influence this to some extent. When for instance, one is working with a broad medium such as charcoal or pastel, then obviously to gain complete freedom of gesture a large sheet of paper is required. For more intimate studies, perhaps produced in a crowded environment, a smaller sketchbook might prove more useful. It is necessary always to think of working in terms of the medium; there is no point for example, in trying to render fine detail with charcoal or pastel.

The more control an artist has over technique, the more he is able to fully realise his ideas. But too much concern with technique will only distract from the things that really matter, and delay the moment when one confronts a subject which demands total concentration. Drawing with a pencil, charcoal, brush or any other medium, is part of a process—a means to an end. There is no special virtue in the perfection of technique as an end in itself. All that is required is that one should be sufficiently in control of the chosen medium to be able to use it with fluency, in order to make one's particular point about the things one chooses to draw.

What matters most is that with the limited tools at your disposal you are able to produce drawings which evoke mood and atmosphere, induce feelings, provide factual information about the structure of a figure or an object, and which reveal previously unseen qualities about things in such a way that you are able to add to your own knowledge about the world and to share it with others. Forget about 'taste' and 'style'—Vollard once informed Degas about a young painter he knew, who after years of struggle, had finally found his true style. 'Well I'm glad I haven't found my style yet' said Degas, 'I'd be bored to death.'

There are no easy ways of learning to draw, and books about drawing techniques, though interesting, are of limited value. It is better in my view to look at the work of great draughtsmen in reproduction form, or better still to see the originals whenever they are exhibited; to look at exhibitions of contemporary drawing; to share ideas and problems with other artists who are confronted with the same problems. But most of all to ask yourself—'What happens if I just try to draw what I can see? And what prejudices if any prevent me from doing this directly?'

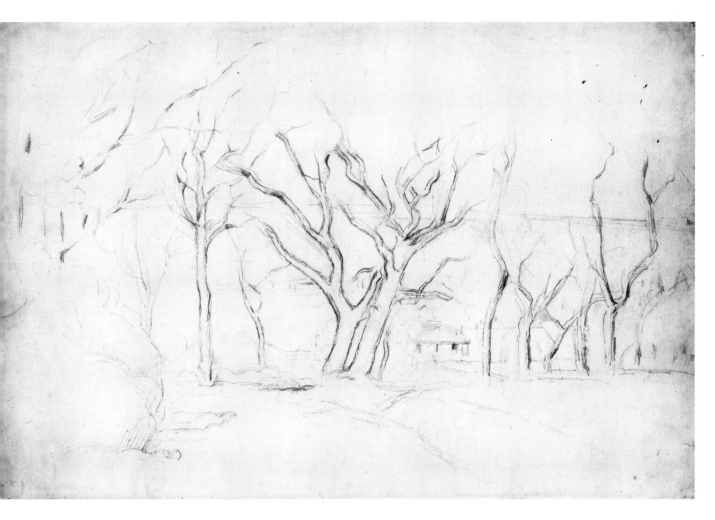

Wooded landscape/Pencil
PAUL CÉZANNE
(Reproduced by courtesy of the
Trustees of the British Museum)

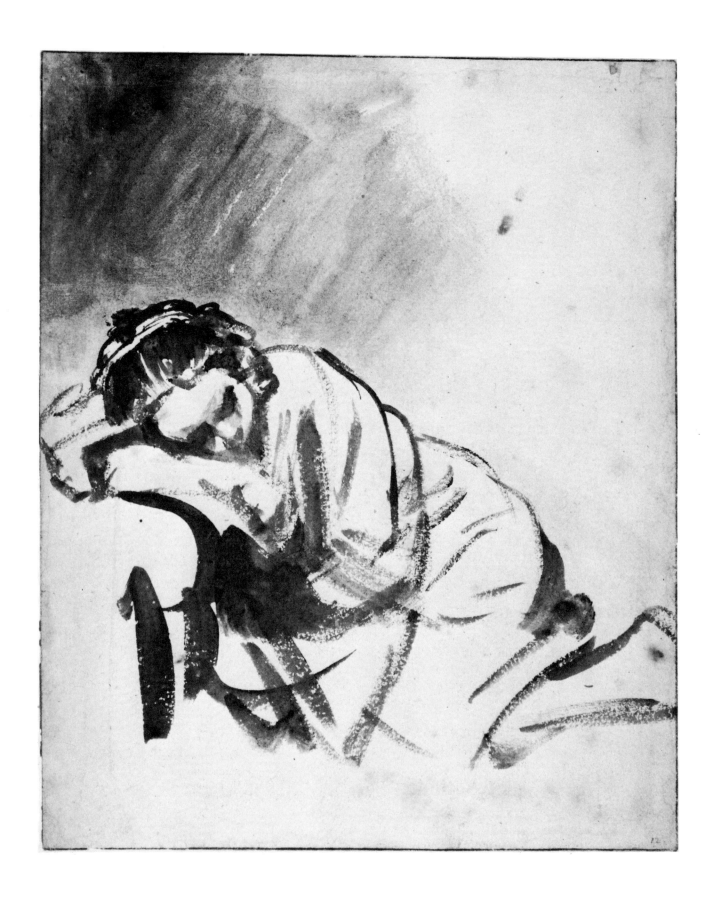

The Human Figure

Because we are human it is natural we should feel a strong motive for making the human figure the most serious of all the subjects we choose to draw.

WHEN WE DRAW THE FIGURE, we are able to confirm for ourselves the uniqueness of each living being. Matisse for example, said that what interested him most was not still-life or landscape, but the human figure. By drawing the figure he was best able to express what he described as 'a nearly religious feeling' towards life.

Figure drawing – or life drawing as it is more generally known – is the most difficult of all subjects to come to terms with; it engages the intellect completely, and can be both mentally and physically exhausting. Equally, for those persistent enough to work with the right degree of concentration, it can be deeply rewarding and enriching. There are no easy solutions – for most of the time we try to coax a likeness from seemingly unco-operative lines, so that all the angles that go to make up a body appear to be right. But there is a danger that what we cannot comprehend, we tend to manufacture.

The problem with life drawing is that there are very few good teachers of the subject, and that it is an extremely difficult subject to teach. Those artists who are given the unenviable task of taking a life class are faced with a dilemma. On the one hand he or she may be expected to ensure an equable measure of achievement developing amongst the group as a whole, and within a short period of time. The students on the other hand expect the teacher to demonstrate some method or technique that can easily be imitated. Imitation is after all the most natural way of learning – the old master-apprentice studio system embodies the concept of learning by imitation. In an effort to make themselves feel more useful, and to make the students feel more involved, some teachers have adopted a dogmatic approach to drawing which demands total loyalty from the student towards a particular style or method. These same teachers sometimes find it necessary to define what art is before their students are allowed to *begin* drawing.

The fact is that all art is ultimately dependent on a physical act. But if that physical act is without intellectual control it runs the risk of simply becoming a clever exercise in graphic technique. Delacroix came nearer to the point when he said that in drawing the imagination conceives, the intellect orders, and the sensibilities execute. Life drawing is dependent on the involvement of the intellect, and this does not mean being overly concerned with exactitude; but that the hand should be guided by the intellect. Bonnard's drawings for instance, rarely appear to be anatomically

OPPOSITE:

Sleeping woman/Brush drawing
REMBRANDT
(Reproduced by courtesy of the Trustees of the British Museum)

correct, yet this very weakness in a large part of his work reveals a subtle intellect and charm.

It is perhaps necessary to make the distinction between bad drawing, and drawings which are contrived to be misleading. We all tend to produce bad drawings – for a variety of reasons; either as the result of careless or hasty observation, or being unable to find the right means of expression. Sometimes we are unable to deal with the complexity of a particular pose, or we simply cannot concentrate. All of this one learns to accept as part of the everyday business of learning to draw. Drawings which I describe as being contrived, are specious in the sense that some artists are primarily concerned with producing images which are conspicuous by their strength of gesture – there is a need to attract attention by producing drawings which are in some way striking. But rarely do such drawings arise from intense observation, or from searching enquiry. All kinds of techniques and mannerisms might be adopted to achieve the required result.

When Michelangelo made use of multiple contours in his crucifixion drawings he was tentatively searching for form, and those drawings possess a palpitating sensitivity which is deeply moving. Yet for some contemporary draughtsmen the use of multiple contours to suggest movement is just another elaborate mannerism.

The act of drawing forces us to concentrate on the subject, but the complexities of the human form are such that one's sense of probity diminishes as a drawing progresses. So that what might start as a searching study of the figure finally ends up as a kind of compromise between marks which verify what we have seen, and marks which are really 'padding' for that which we are no longer able to comprehend – what Sickert called the 'upholstery' of the drawing. If attention is concentrated on a particular part of the body, the face or hands for example, not much will be perceived of the remaining parts of the anatomy. If on the other hand one tries to take in the whole figure, no one part can be clearly or accurately visualised. So life drawing demands that we concentrate not just on individual parts of the body, but on the totality or summation of each part in relation to the other. At the same time we must be conscious of the fact that the figure must be drawn in such a way to suggest that it is capable of movement, and not just an inanimate dummy. Things change even while we are observing them, and we are not always sufficiently visually agile to incorporate the changes as they occur.

It has been my experience that having spent five or six hours drawing the same pose, I sometimes produce a drawing which is disappointing in that it is too far removed from that which I had hoped to achieve. Then

OPPOSITE:

Standing figure/Charcoal
Thirty-minute study following a series
of earlier drawings in pencil

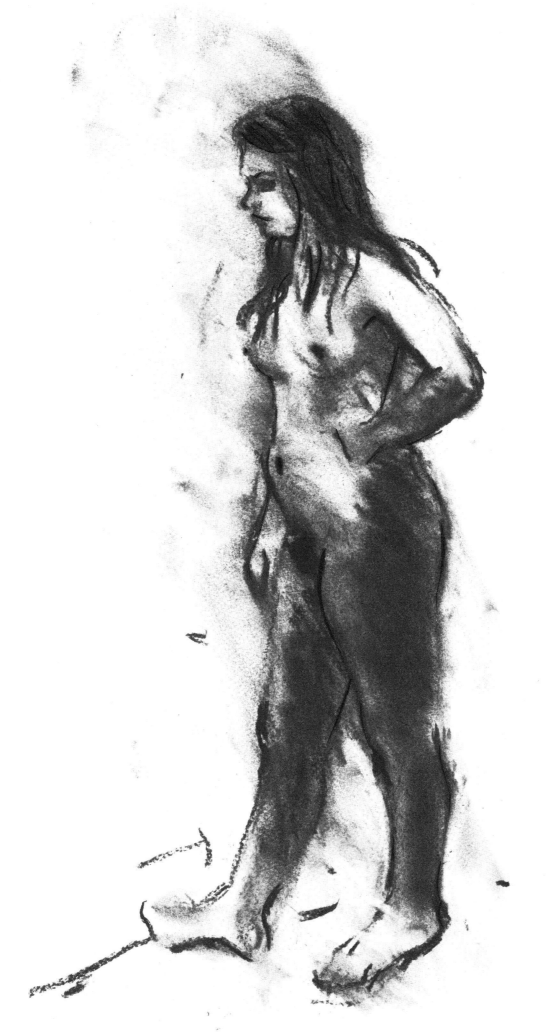

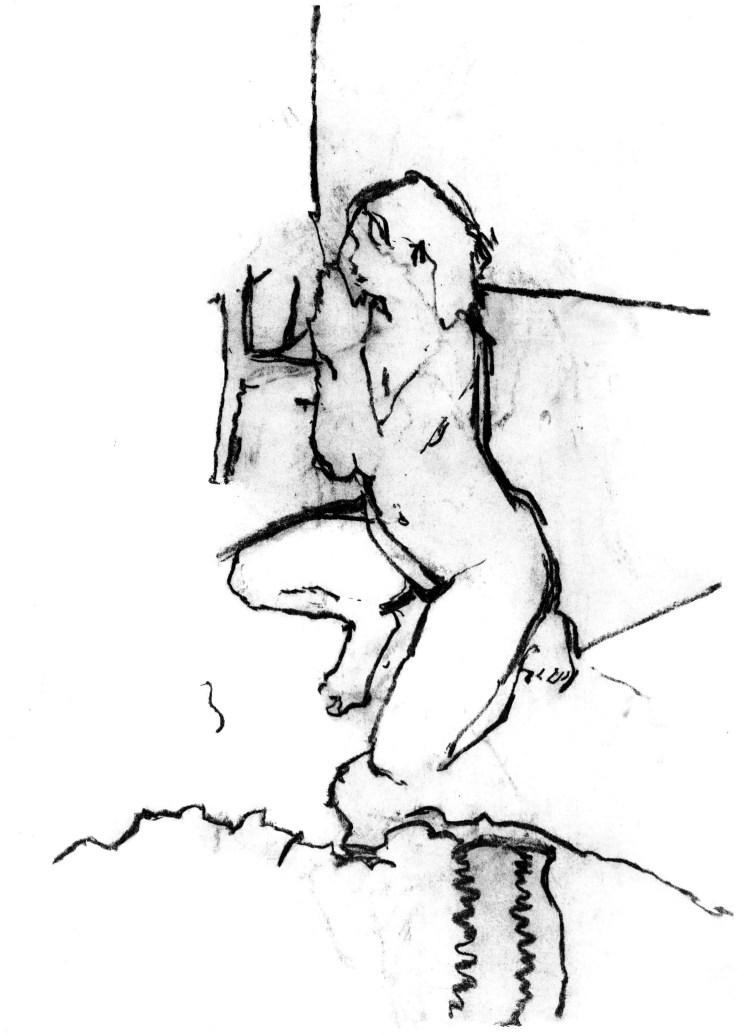

in order to compensate for that sense of disappointment, I end the day with a short ten-minute study. More often than not this last study is much more successful. This is because one has assimilated all the qualities that are particular to the pose throughout the day, and therefore one is better equipped to make a convincing statement which does not need revision or reconsideration. So time spent producing a drawing which turns out to be unsatisfactory is never wasted, even though it is difficult sometimes not to feel discouraged.

Before one begins to draw the model it is necessary to realise fully the significance of the pose, and to assess the essential characteristics of the person sitting before us. What exactly are we trying to express? Are we striving for a likeness? And if so, what do we mean by a likeness? 'The model' said Renoir, 'is there only to set me alight, to let me dare the things I could never imagine without it . . . and it makes me come a cropper if ever I go too far.' Renoir needed a model or motif as a stimulus, and as a check to prevent his imagination from straying too far.

My belief that the draughtsman sees more than others should also mean that he is sensitive to both the physical and spiritual presence of the model – to see qualities which are not easily discerned. To bring out such qualities it might be necessary to give emphasis in the drawing to certain traits and features which are particular to the model. The kind of qualities in fact which Rubens and Rembrandt were able to bring to their drawings, which somehow go beyond what can be recorded by a purely mechanical process such as photography. There are of course some photographers like Weston or Brandt for instance, whose work transcends mere documentation, but on the whole most photographs of the figure are contrived to conform to the accepted notions of 'idealised' beauty and fashion. By using special studio lighting, lenses and filters, and just occasionally the services of a photographic retoucher, all blemishes and imperfections can be removed. The problem here is that this kind of photography has in turn influenced the way that people see the figure, so that students for instance, might initially attempt to produce drawings with that same idealised quality of the photograph. Their drawings are given a photographic sheen with tonal values simulating the soft gradations of the black-and-white bromide print.

The activity of life drawing has always aroused a certain amount of suspicion, and the relationship between artist and model a subject for satire and wit. Some models have their own ideas for posing. I remember arriving in the life room one morning where an athletic male model had been booked for the class. He carried a bag full of props and asked me

OPPOSITE:

Kneeling figure/Charcoal
The emphasis on the contour, gives the drawing a strong sense of design
CHRISTOPHER CHAMBERLAIN

what kind of pose I would like. When I asked what he could do, he proceeded to go through a sequence of poses starting with Robin Hood on bended knee drawing an imaginary bow, to his own version of the Haarlem Globetrotters, complete with bouncing ball. 'Then of course' he said, 'there's my baby oil'. 'And what exactly do you do with that?' I asked incredulously. 'I rub it into the skin' he said, 'and when you put the lights on you get the benefit of all the texture!'

But the particular contribution made by the model to the success of a drawing is often underestimated. If for example, the model who has been hired is bored, disinterested and impatient, one can sense that this is so. The working atmosphere might then be disturbed to such a degree that no amount of concentrated effort by the artist will enable him to produce anything worthwhile. The model who participates fully in the working session by trying to anticipate the requirements of the artist, will undoubtedly contribute a great deal.

Every model possesses certain individual characteristics which are best brought out by the choice of pose, the particular setting, the arrangements of related objects in the room, and the quality of light. I usually find that it takes three or four separate sittings before I can discover how to get the most suitable pose from a model. Some younger models for instance, might work well with a series of short poses of an arrested movement – kneeling, stooping, stretching and so on. Older models might have the kind of calm composure which is best registered by longer and more painstaking analysis.

Standing poses are difficult for both artist and model alike. The sense of weight becomes more critical, one leg usually bearing more weight than the other so that there is a need right away to establish the vertical axis of the leg which is supporting the rest of the body. The formality of a set pose can often seem unnatural – whenever one asks the model to rest for instance, he or she will inevitably fall into the kind of pose that one had been searching for in the first place. Yet paradoxically, if one had *asked* the model to assume a relaxed pose it would again be quite different.

Just as one might move from place to place to find the right view-point when drawing a landscape, so one should also view the model from different angles, and if possible from different levels. A reclining pose for example, might appear more interesting if drawn from a high vantage point such as a table-top. It is usual for the artist to work about three metres distant from the model, but much depends on exactly what you are trying to establish in the drawing, and there is no real need to keep to a fixed position.

→ page 38

OPPOSITE:

Seated figure/Charcoal
An informal study rendered with considerable sensitivity
CHRISTOPHER CHAMBERLAIN

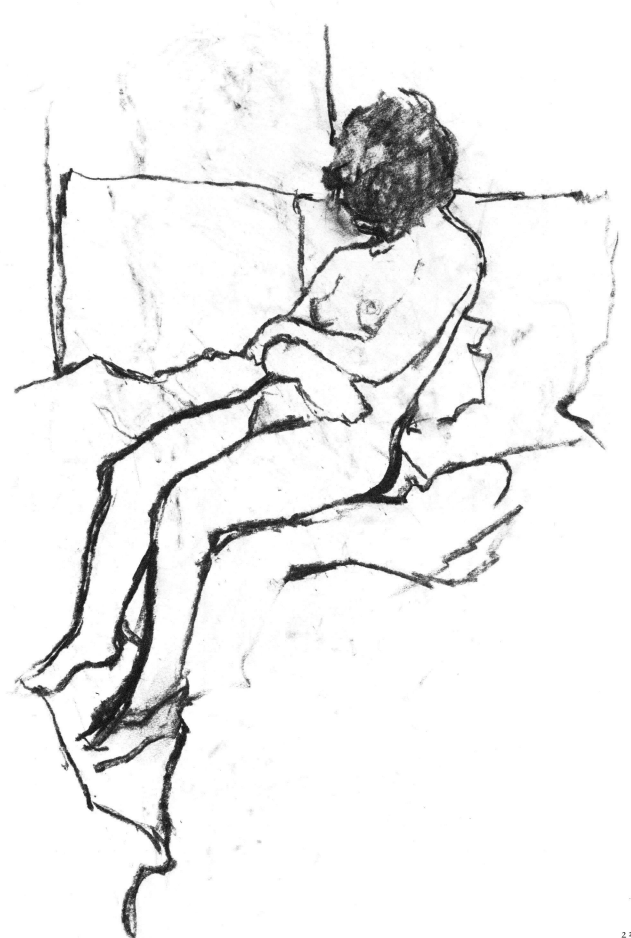

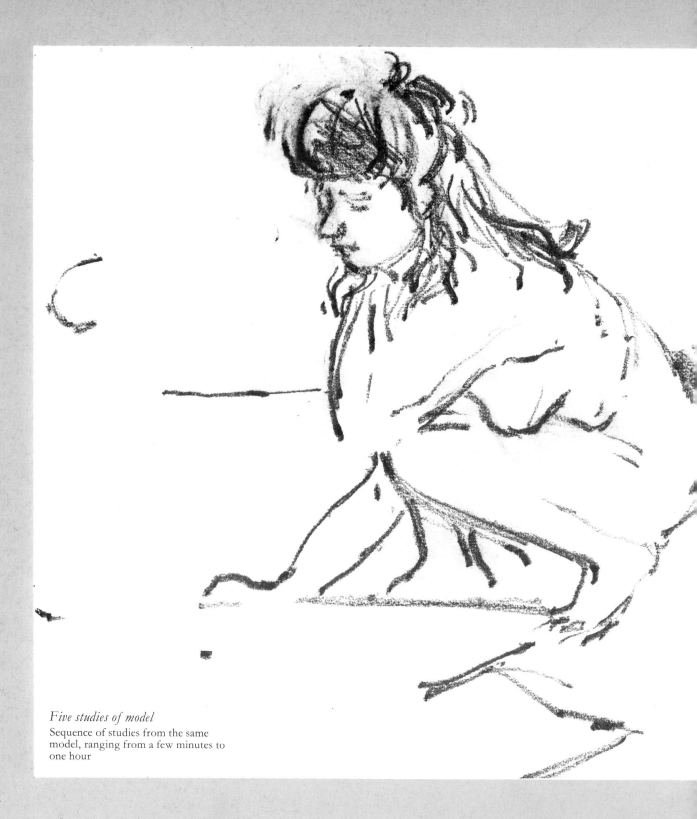

Five studies of model
Sequence of studies from the same
model, ranging from a few minutes to
one hour

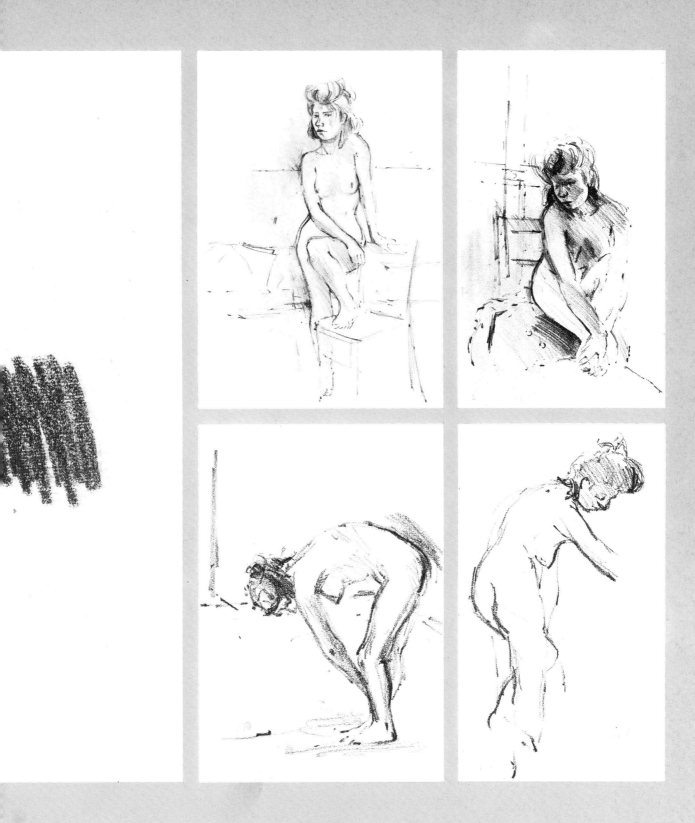

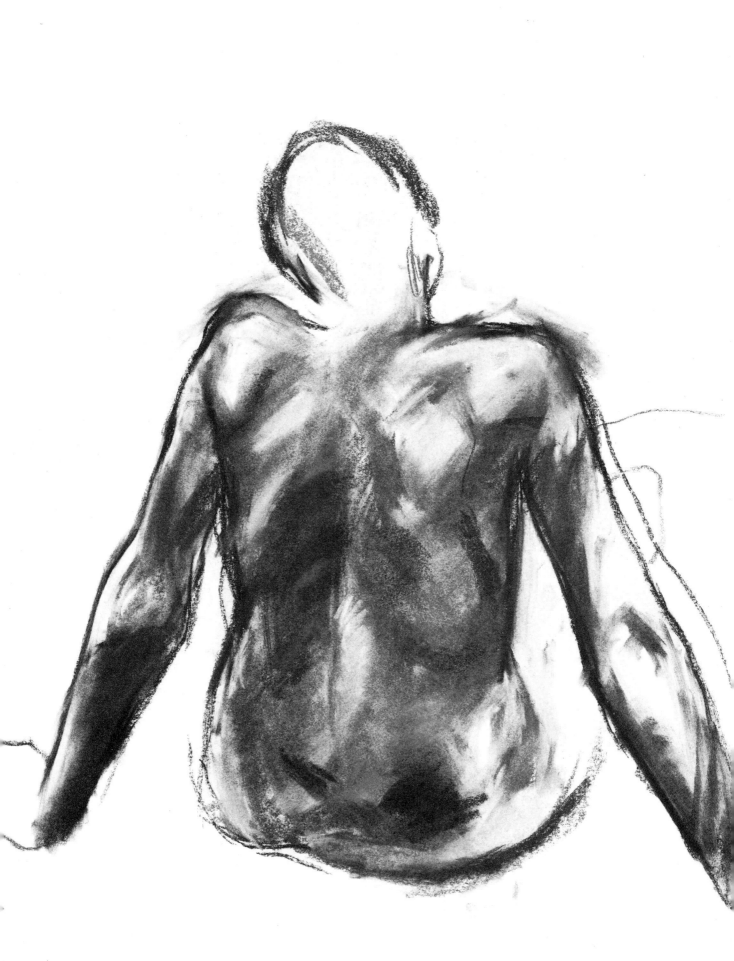

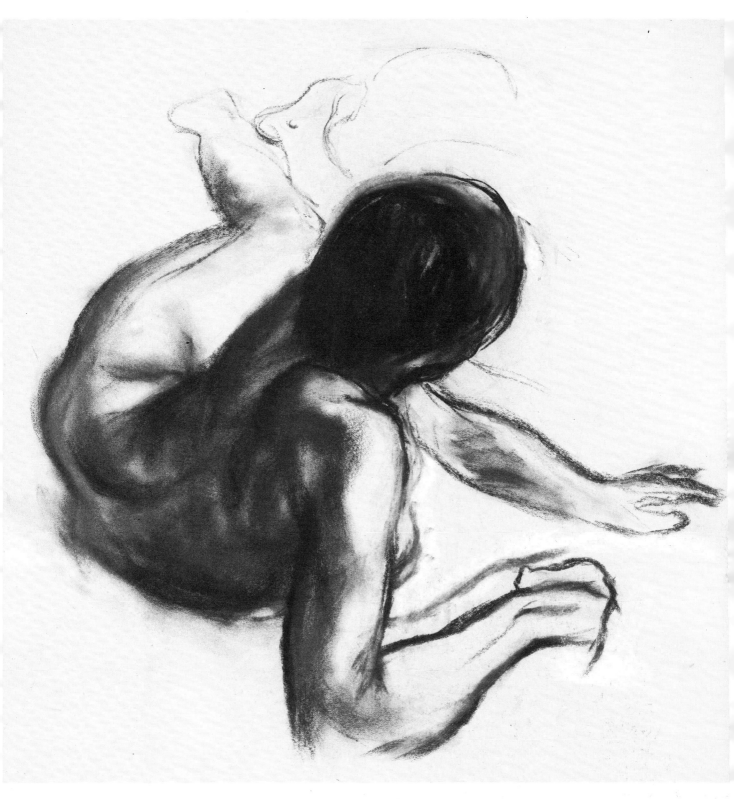

Reclining figure/Pastel on toned paper
Seen from a carefully selected viewpoint,
this drawing has a strong sense of rhythm

Seated figure/Pastel
A convincing study (*left*) of the tautness
of back muscles
KATE DAVIES

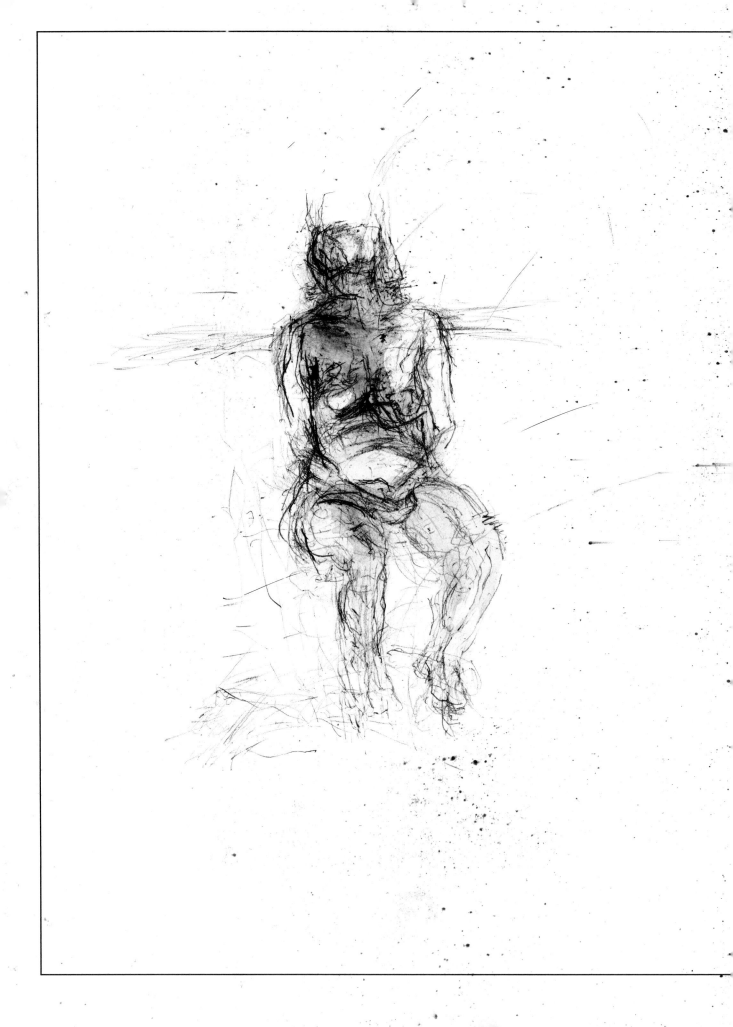

Seated figure/Pencil
A drawing which tentatively registers
the artist's considerable sensitivity to the
subject
CHRISTOPHER PEMBERTON

*Nude study/Soft pencil on coarse
texture paper*
An intimate drawing which relies on
understatement

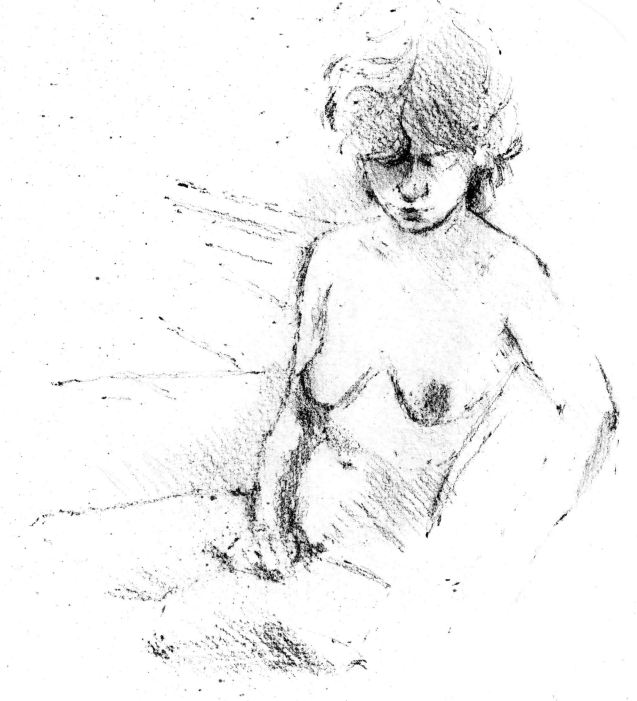

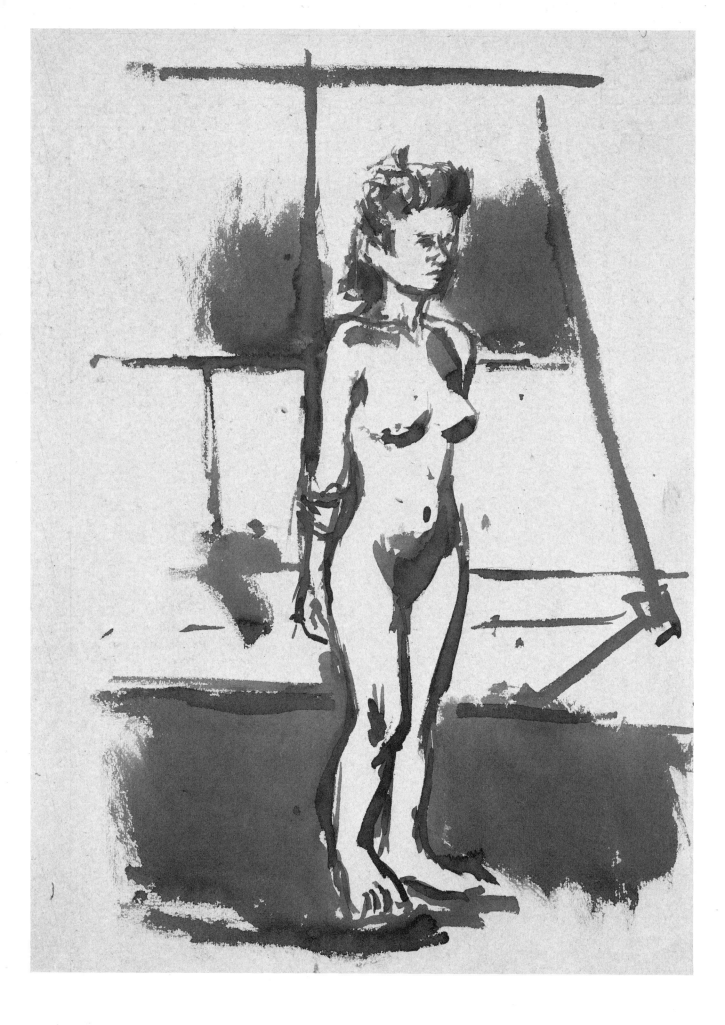

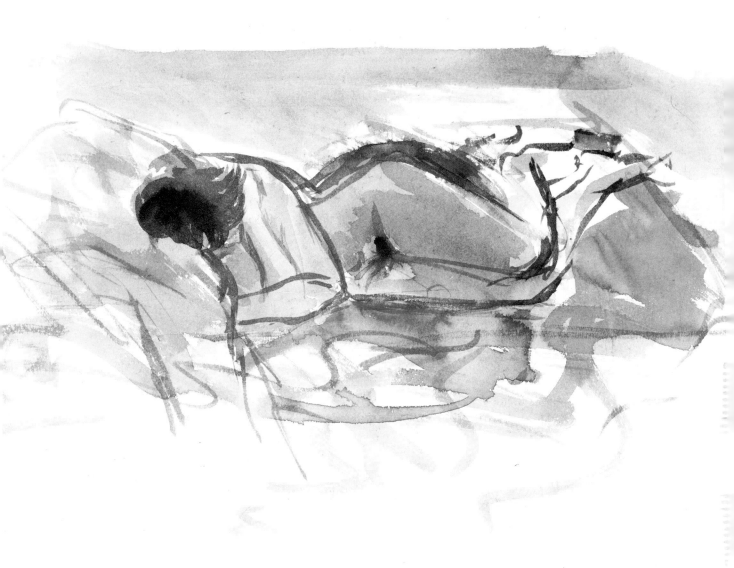

Reclining figure/Brush drawing
Soft brush marks give the drawing a
fluency which is difficult to obtain in
any other medium

OPPOSITE:

*Standing figure/Brush drawing on
toned paper*
The vertical pose of the figure relates to
other components of the drawing

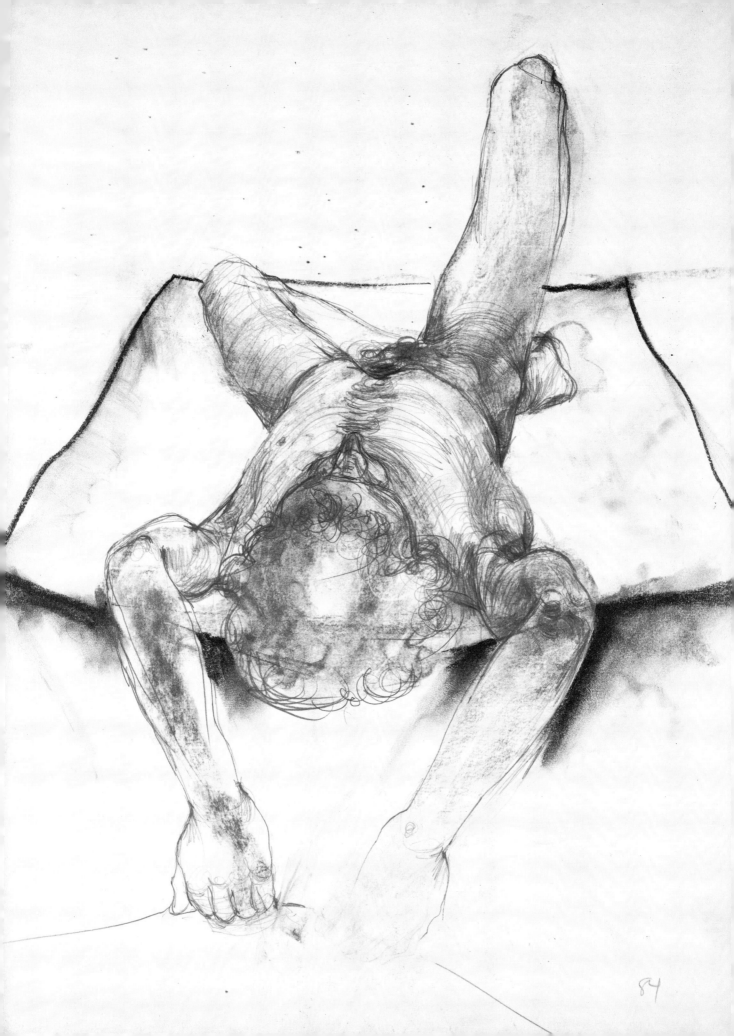

84

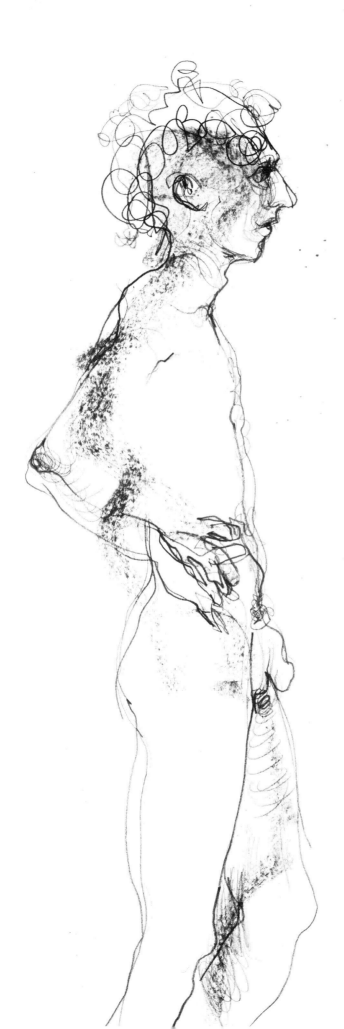

Standing figure/Pencil and charcoal
ROLAND JARVIS

OPPOSITE:

Reclining figure/Charcoal and pencil
ROLAND JARVIS

33

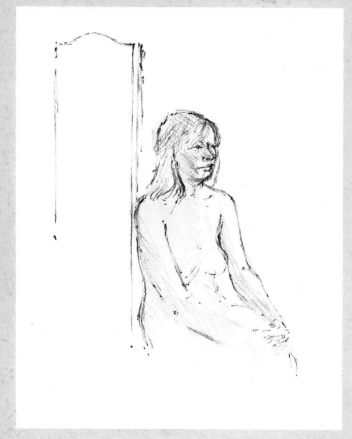

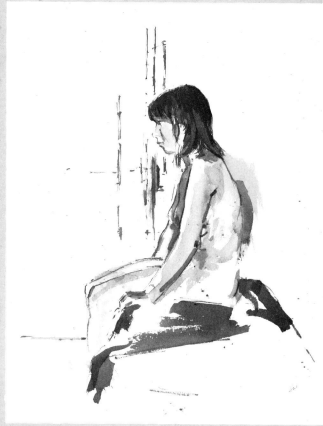

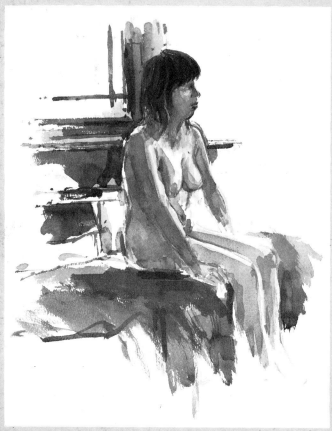

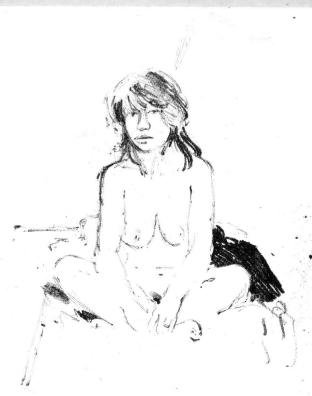

Series of eight informal studies/Pencil and watercolour

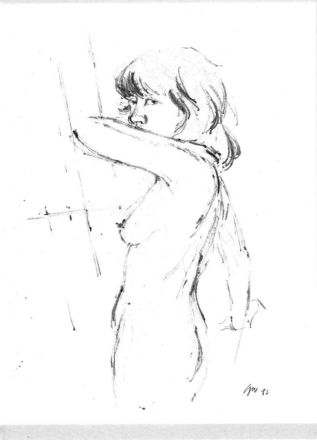

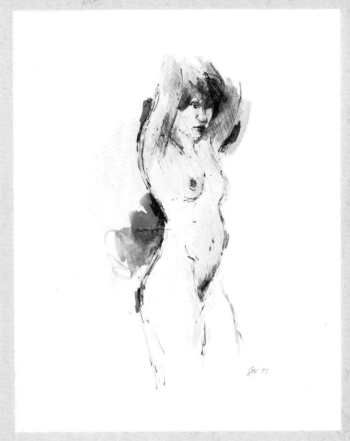

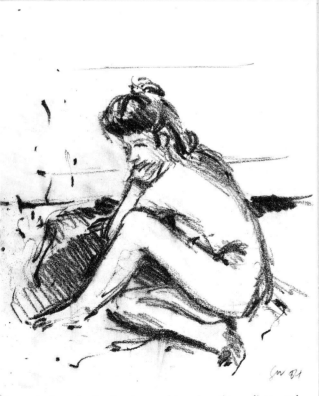

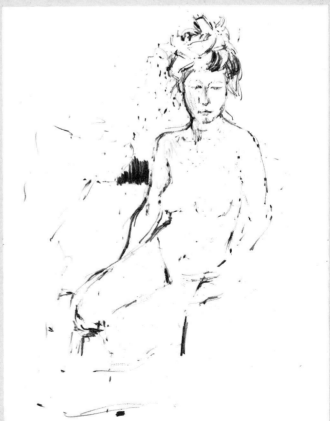

The particular attitude of each pose determines the medium used

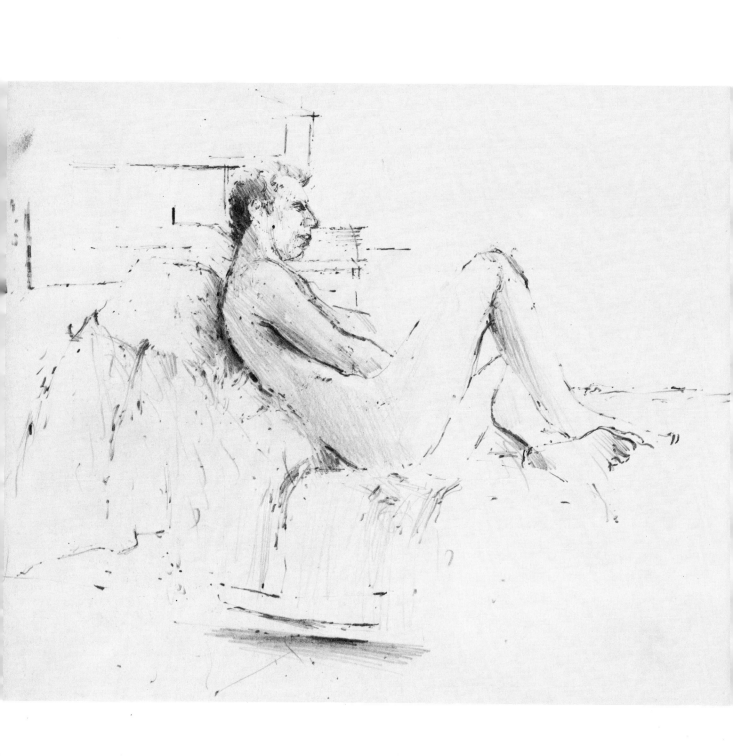

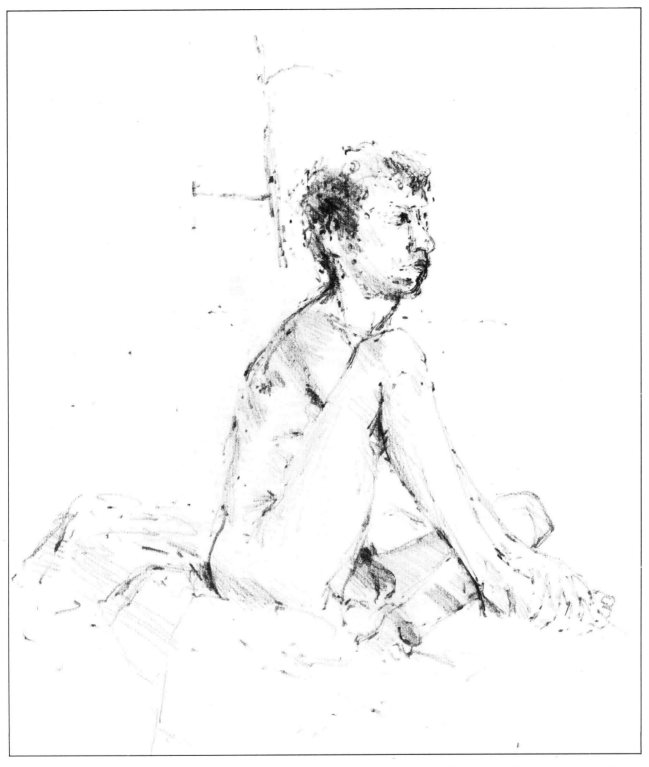

Two studies/Hard and soft pencil
Two studies of the same model; the first in hard pencil (*left*) is from a sitting of forty-five minutes. The second in soft pencil is from a much shorter pose. I tried to suggest something of the contemplative mood of the sitter, who is also a writer

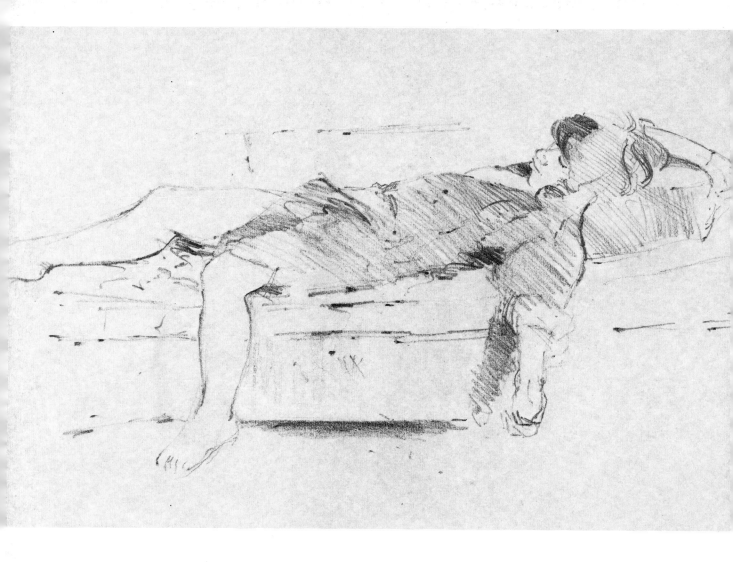

Model resting/Pencil on toned paper
An informal study of the model resting between sittings

OPPOSITE:

Model in armchair/Pencil
An old armchair makes a useful prop for the slender figure of this model

According to the academic tradition of life drawing, the figure should be drawn without reference to the background or surrounding objects. This still persists today in some life drawing classes—a great pity in my view, since I find it particularly useful to relate the figure to the background, even if one is simply indicating the base lines of the floorboards or adjacent doors and windows. All the related horizontal and vertical structures in the studio provide a means of cross reference when drawing the model, using the position of chairs, tables, fireplaces and so on as reference points. It is also interesting compositionally to see the way that the shape of the body cuts into objects. Some thought might be given to the way that the figure is posed in relation to everything else in the studio, but a background that is too confused can make it difficult to distinguish the figure from the surrounding objects. Two-thirds of the drawing for example, might be taken up with floor space leading to the figure in the distance. Alternatively a single chair supporting the model may be all that is required.

When we begin to draw the model we draw contour lines around arms and legs, and those parts of the anatomy we can readily identify. The mind delights in unity, so we try to connect various parts of the body by positively stated lines and, where the line is broken, by inference. But just as the cube, cylinder and sphere can be described by line alone, to suggest solidity we need to use tone. And whilst it is possible to hint at volume by

→ *page 42*

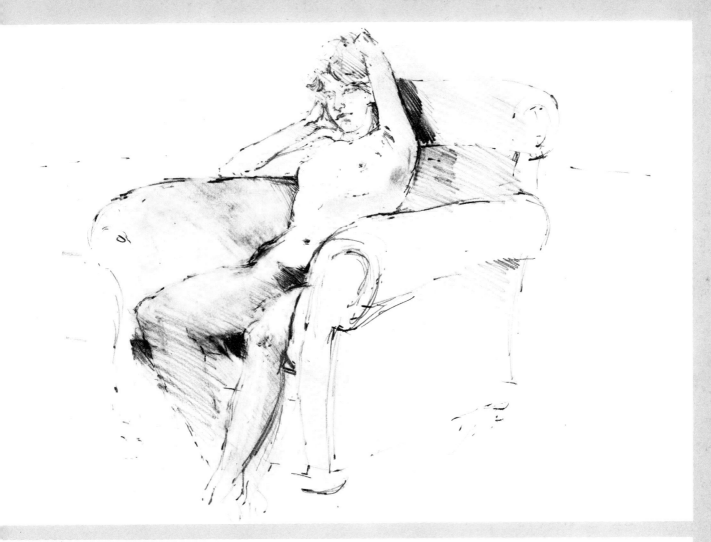

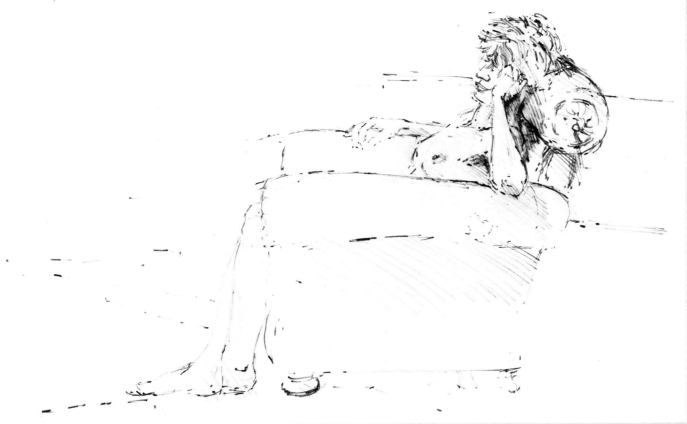

Reclining figure/Charcoal

DRAWING: THE HUMAN FIGURE

using line in a particular way, we must use tone to render the sculptural qualities of the human form. Ingres said that to draw does not mean using contours alone, but that one should also be concerned with expressing the inner form, the plane and modelling.

Most students experience difficulty in trying to use line and tone together. Quite often tones are too strongly contrasted, or there is a disparity between the strength of the line and tone. Where closely drawn lines or shading are intended to suggest tone, the lines can become too mechanical. And again, charcoal which is pushed around the surface of the paper can create confusion unless one takes account of the direction of light and shadow in relation to the pose. Charcoal is a useful medium for those who are beginning life drawing; it responds to the slightest touch and produces broad marks which can be wiped away with a finger. The broadness of the line it makes also prevents one from becoming too concerned with rendering fine detail. The use of a fountain pen with a broad nib and washes of ink might also be tried. But whatever medium or combination of media one uses, one should always try to work in terms of the particular qualities they produce. Pens, brushes and charcoal give a particular quality of line which can be exploited. When one looks at a charcoal drawing by Degas or a pen drawing by Rembrandt, this becomes more obvious. Degas used charcoal at full strength to give emphasis to contours, and softer tones appear to be almost brushed over the surface of the paper, with white chalk used occasionally to heighten the lighter planes. And again, in Bonnard's life drawings there is no conspicuous separation between line and tone.

The early drawings of the great painters tend to show a preoccupation with academic detail. Later, in the development of their work, one sees how superfluous detail is stripped away to reveal only that which is essential: the drawings work by inference, rather than by being too explicit in detail. Much depends of course on the particular temperament of the artist. Ingres reckoned that it takes thirty years to learn to draw, and three days to learn to paint. This sober statement may sound unduly discouraging, but I can only say that having produced drawings more or less continuously for almost exactly that period of time, I still feel I am at the beginning of things. There is a space which divides understanding from expression, and I believe that learning to draw means learning to narrow that space.

OPPOSITE:

Reclining figure/Pencil

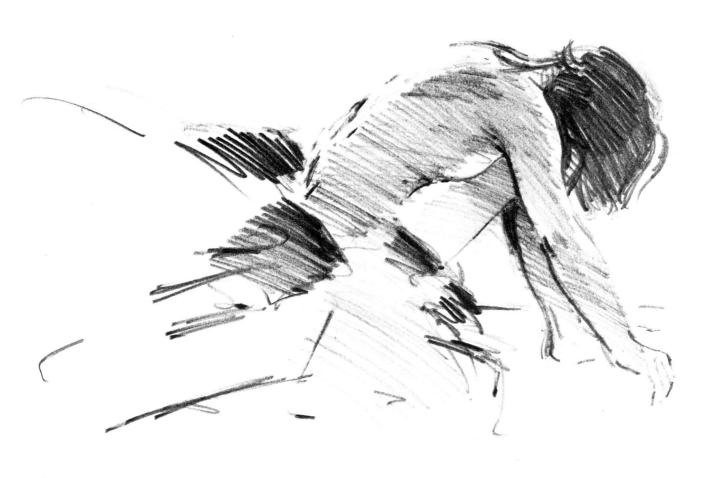

Seated figure/Pencil
A drawing made at the end of a
day's sitting

DRAWING: THE HUMAN FIGURE

Figure/Pencil and Charcoal
The unusual viewpoint gives the drawing
a dynamic quality
ROLAND JARVIS

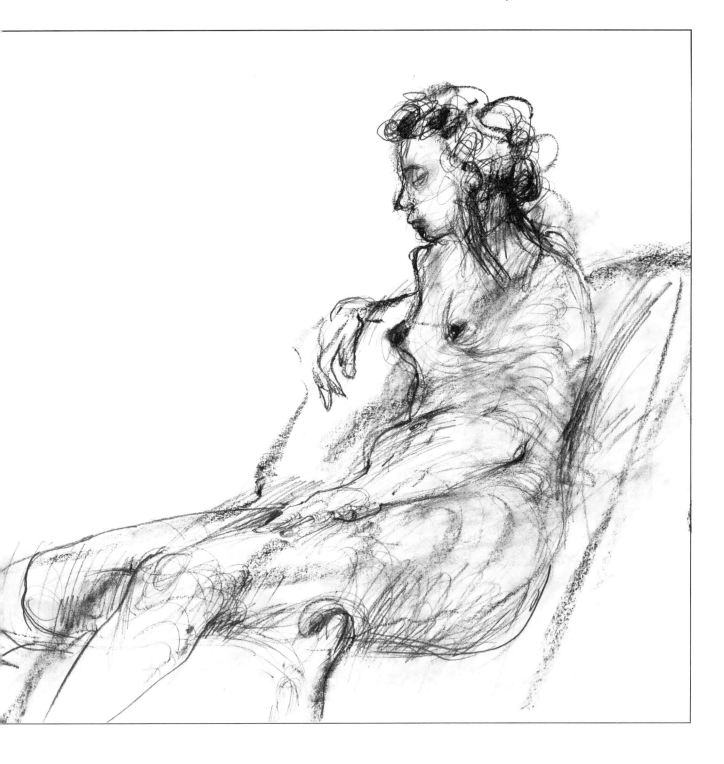

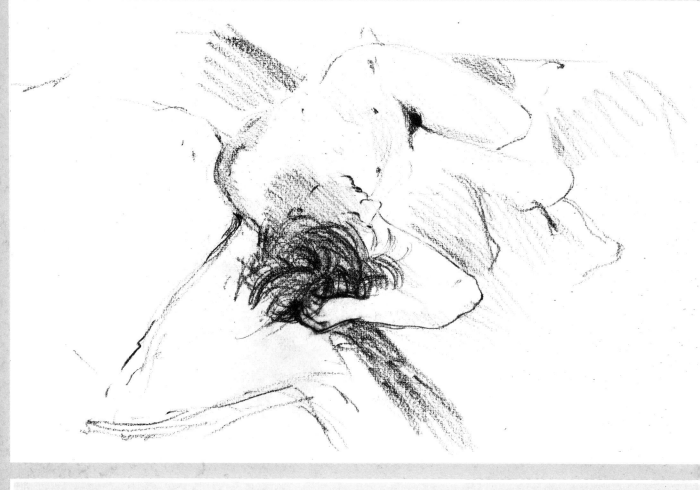

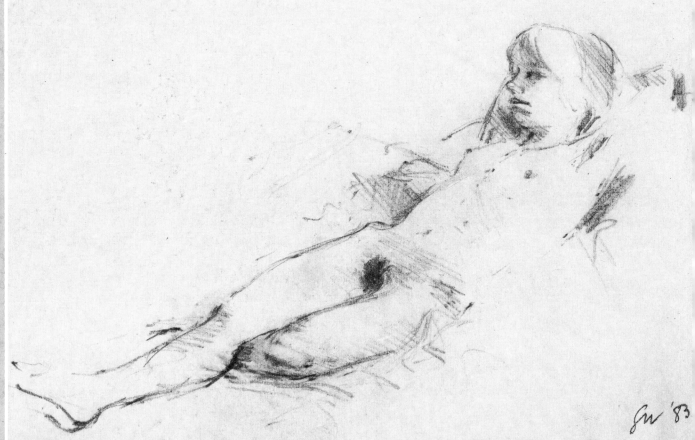

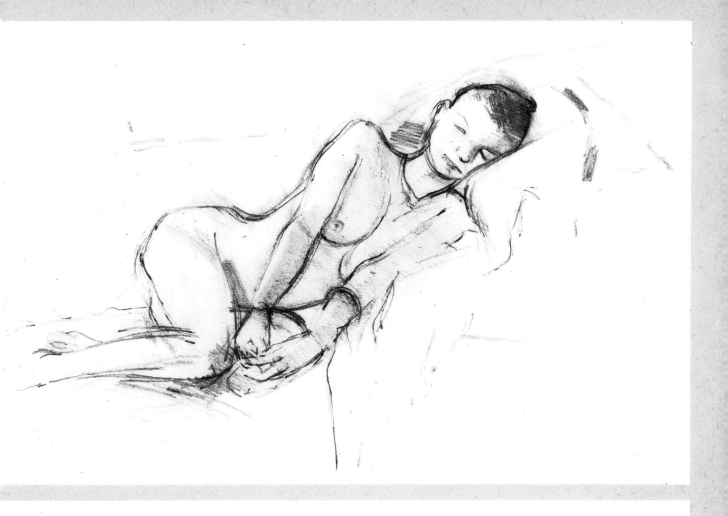

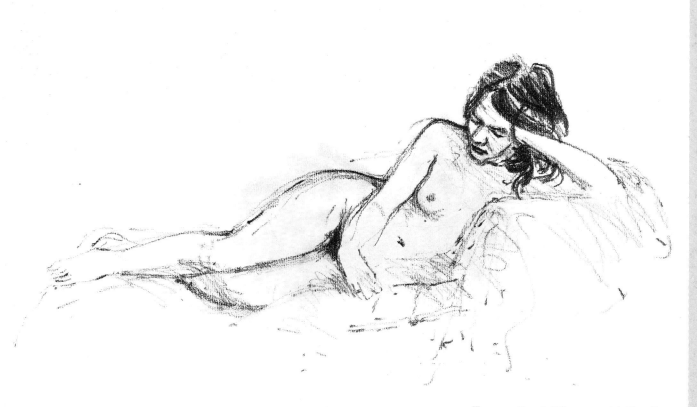

Four studies of different models/Pencil

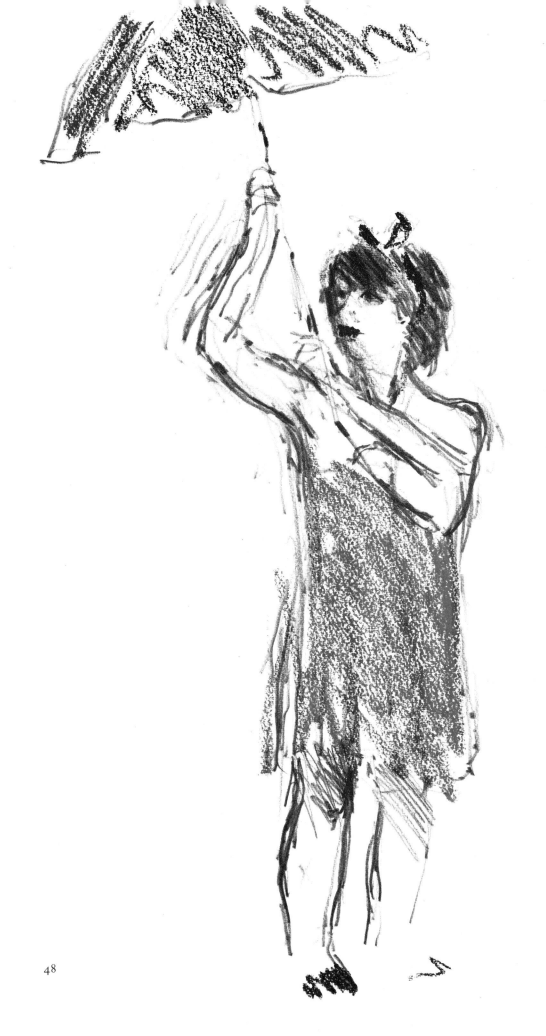

People & Places

To draw the figure in the context of everyday situations we must necessarily escape from the academic environment of the studio.

WHEN WE ARE WORKING in a drawing studio we have a certain amount of control over the way that everything is disposed according to our own requirements. But to draw the figure in the context of everyday situations we must necessarily escape from the academic environment of the studio, and go out into railway stations, factories, hospitals, sports grounds, and wherever people congregate for one reason or another.

Among the most interesting of the paintings produced by the French Impressionists were their inconsequential studies of men, women and children idly engaged in casual pursuits – Seurat's riverside sketches for La Grande Jatte for example, or Vuillard's atmospheric interiors of old women sewing or reading by lamplight. There are a great number of examples of artists finding interesting subjects, even in the most unexpected circumstances.

Today, film and photography have largely displaced the role of the artist as a reporter in documenting sociological problems. Yet because we are saturated by photographic information in one form or another, the particular contribution made by the draughtsman can still demonstrate a conspicuous poignancy. When one looks at the problems of the old and infirm for instance, there have been many fine documentary films and photographic essays which have served to stimulate our interest in the problem. But the drawings by Anthony Eyton, which he produced over a period of time in geriatric hospitals, have for me a special significance as the images sink in and begin to accrue in the mind. He has somehow managed to produce drawings which compassionately evoke the communal spirit of elderly people, defiantly cheerful, as they recall the songs long remembered from nights spent in air-raid shelters and underground stations during the London blitz.

The drawings of Indian villages, in contrast, demonstrate Eyton's gift for dealing with crowds. There is no clear outline in these drawings, or extreme contrasts of light and shadow, yet he describes with conviction all the heat and dust and colour of the market place. They are drawings which recall for me the sketchbooks that Delacroix produced in Morocco and north Africa.

The studies of musicians by Patrick Symons are the result of intense analysis. About his recent work he has said he is trying to produce settled pictures from things that move a little – such as leaves on trees and string players. Some results can be seen on pages 58–61.

OPPOSITE:

Model with parasol/Pencil and wax crayon
Some models love to dress up and enjoy acting. This drawing was made in a few minutes before the pose became more formal

Day patients in a geriatric hospital,
and Dorothy singing 'Show me the
way to go home'/Charcoal
ANTHONY EYTON RA

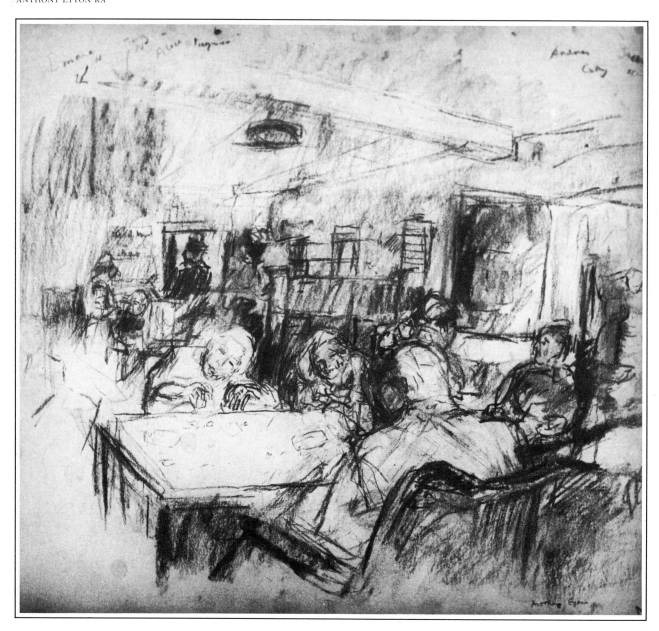

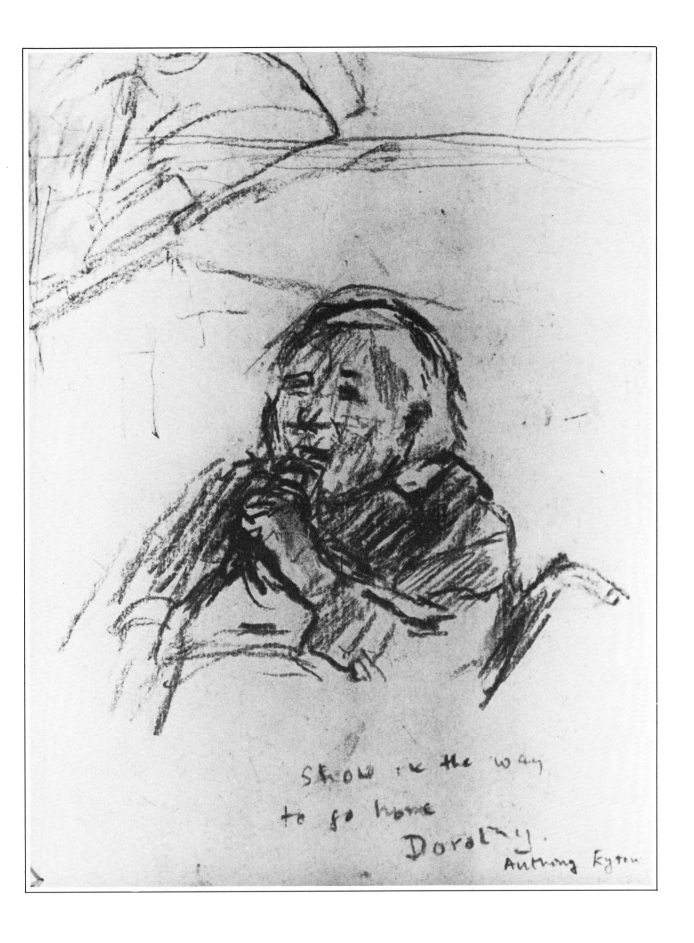

Show me the way
to go home
Dorothy.
Anthony Eyton

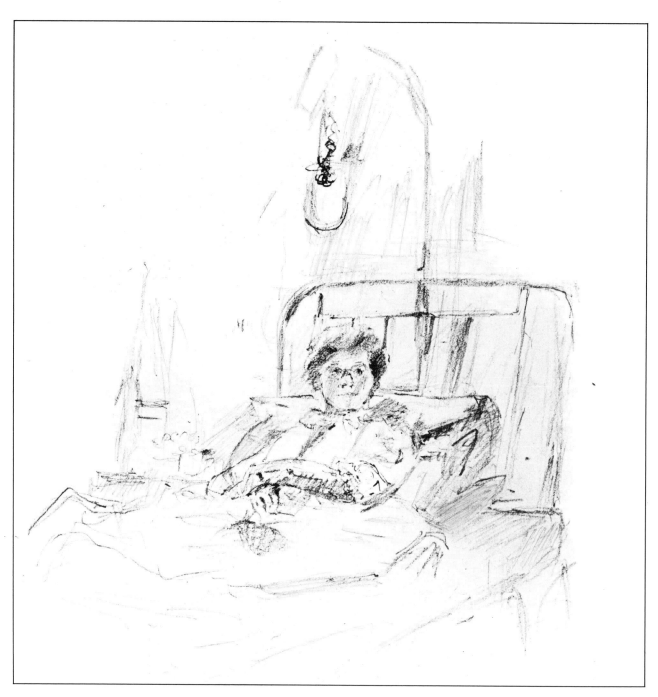

Hospital patient/Pencil
ANTHONY EYTON RA

OPPOSITE:

Escalator/Charcoal and pencil
The artist has made a number of studies
of people moving about railway termini.
Some of the older stations such as
Liverpool Street in London, provide the
opportunity of seeing people at different
levels at the same time – on platforms,
overhead walkways, and descending into
underground platforms
ANTHONY EYTON RA

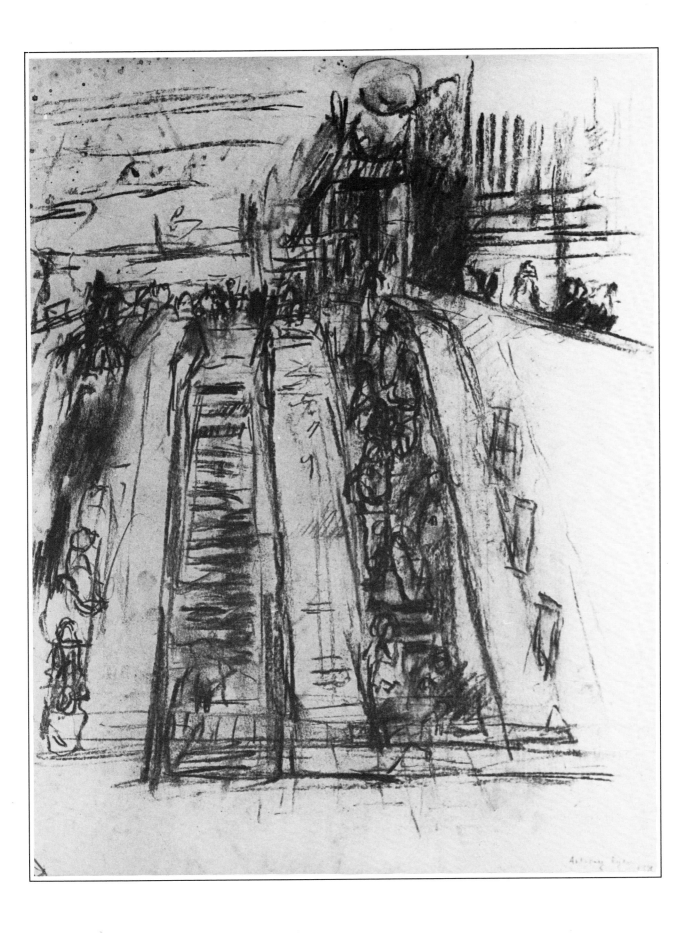

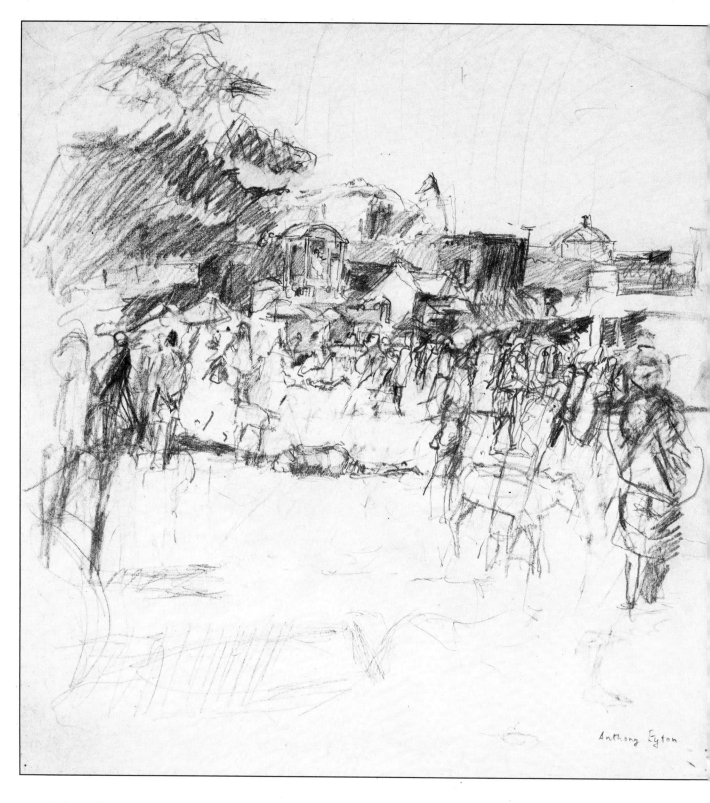

Indian village/Pencil
ANTHONY EYTON RA

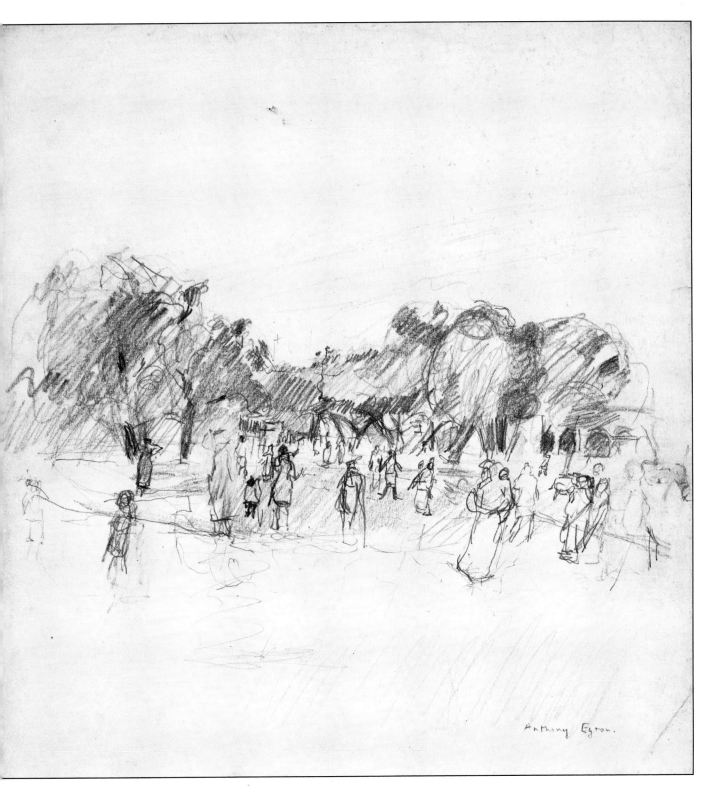

Tanjori Palace Gardens/Pencil
ANTHONY EYTON RA

Soldiers at Greenham Common/Pencil and wash

The artist made a number of visits to the women's peace camp at the Greenham Common missile base

TABITHA SALMON

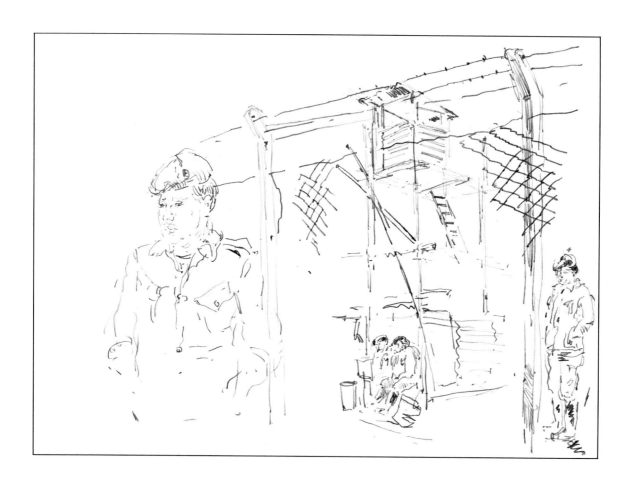

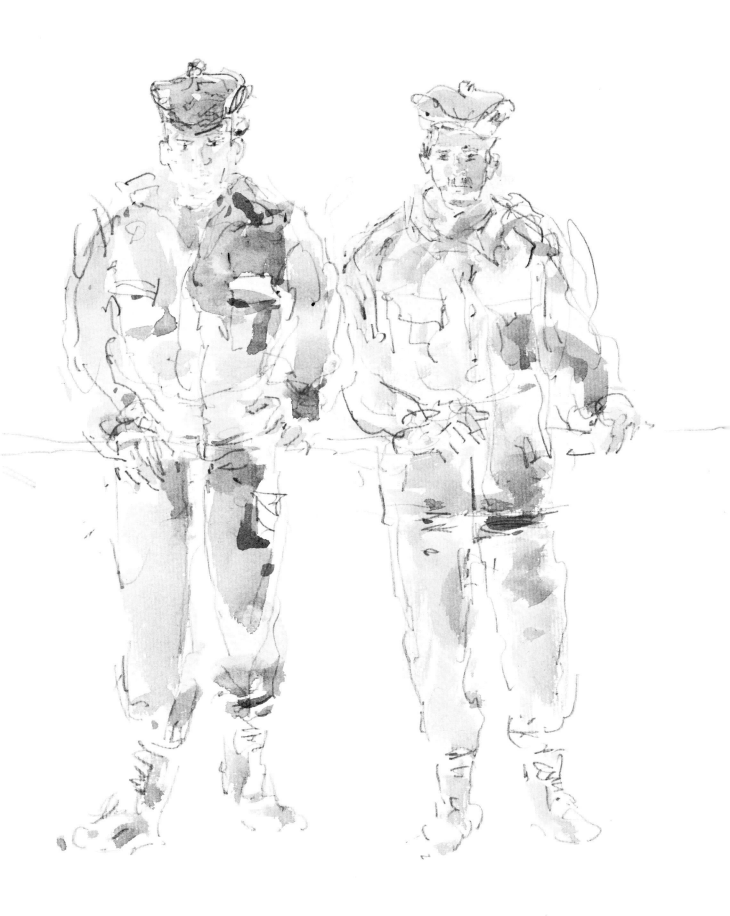

Study for trio rehearsing/Pencil

Trio rehearsing/Charcoal

To produce settled pictures from things
that move a little it is necessary for the
artist to work for long periods of time
from direct observation of the subject.
Initially he produces what he calls
scribbles to sort out the structure
(*see opposite*), which will eventually serve
as a kind of scaffold for the finished
picture. He draws most often in charcoal,
sharpened by breaking the stem
PATRICK SYMONS

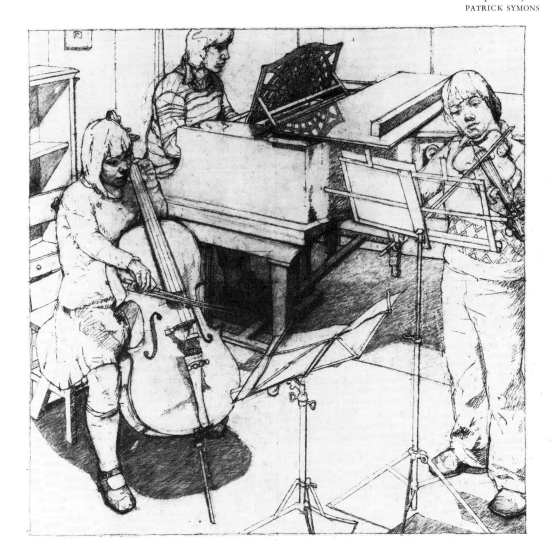

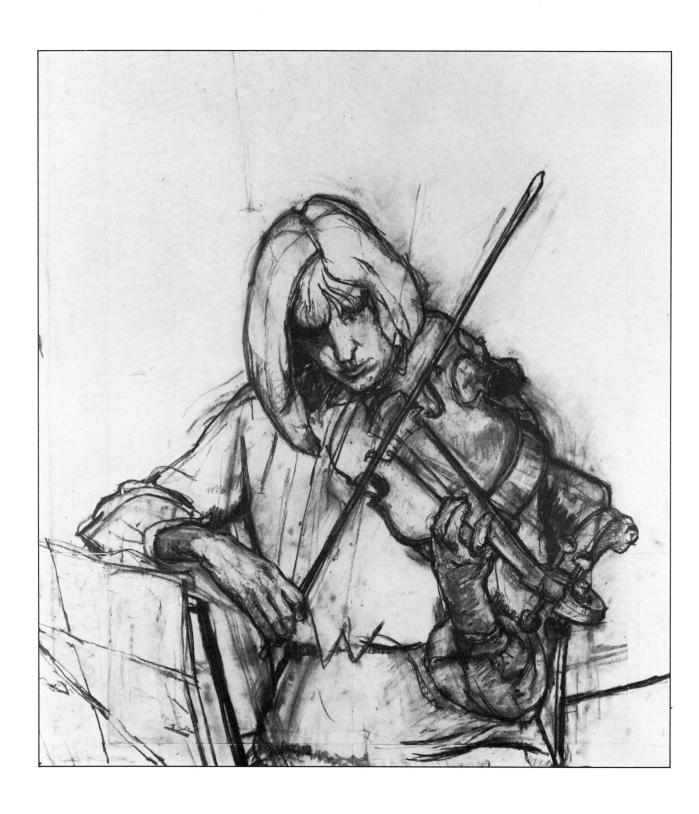

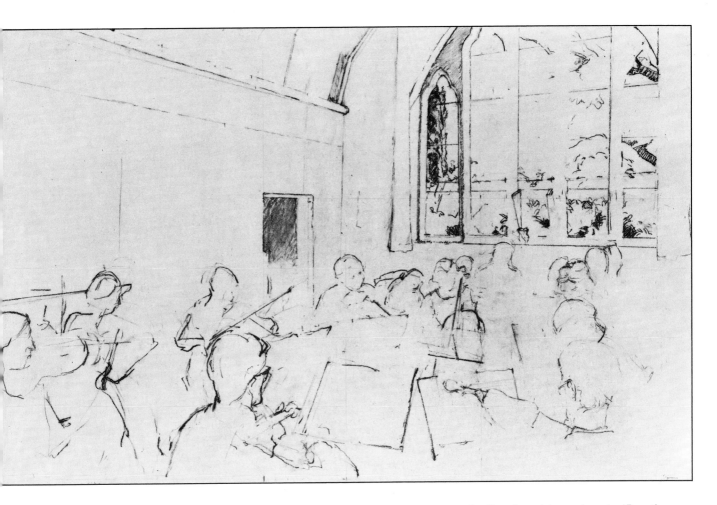

Studies of musicians rehearsing/Pencil
Musicians in constant movement require
a considerable amount of discipline from
the artist in having to make rapid
judgements visually
PATRICK SYMONS

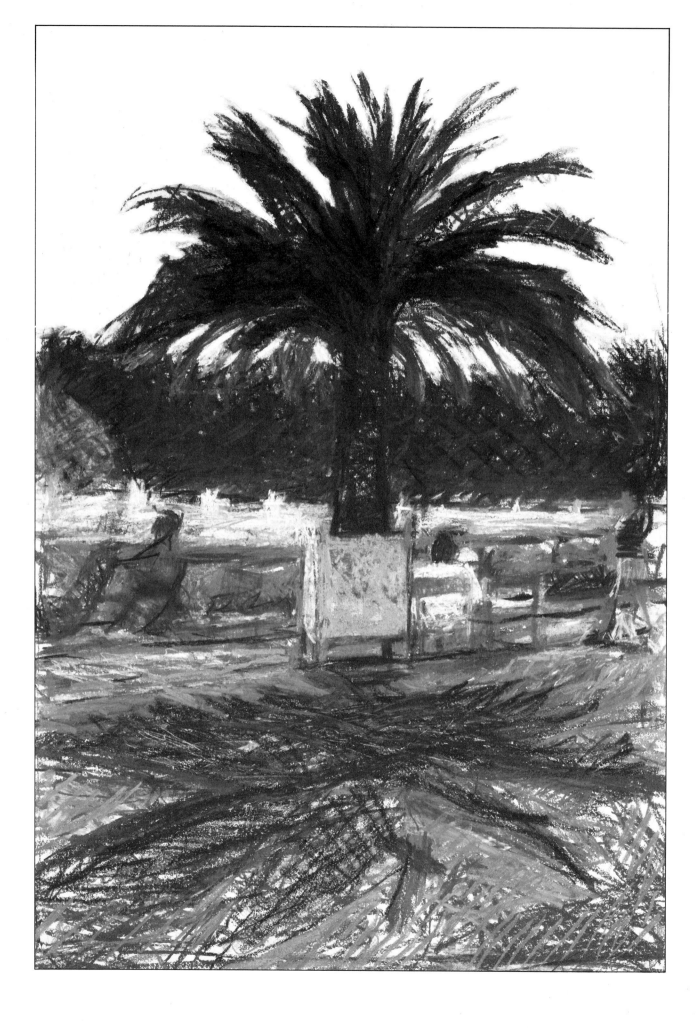

Girl in a deckchair/Soft pencil
An informal study which is full of
warmth and charm
HENRY INLANDER

OPPOSITE:

Palm in the Luxembourg/Pastel
A strong drawing in which the figure is
dwarfed by a palm in the Luxembourg
gardens, Paris
RANDALL COOKE

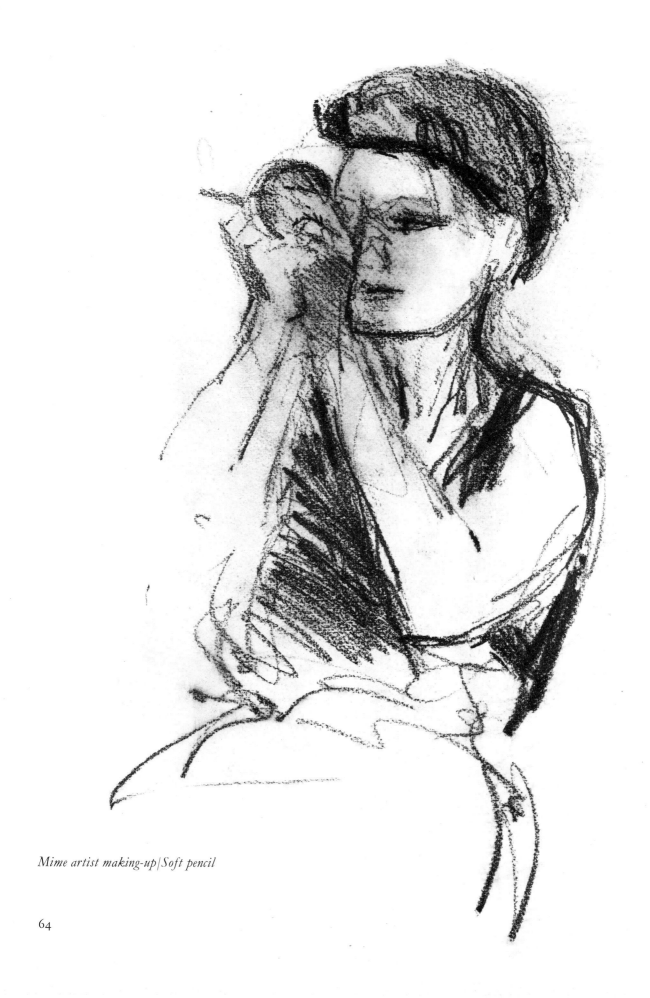

Mime artist making-up/Soft pencil

64

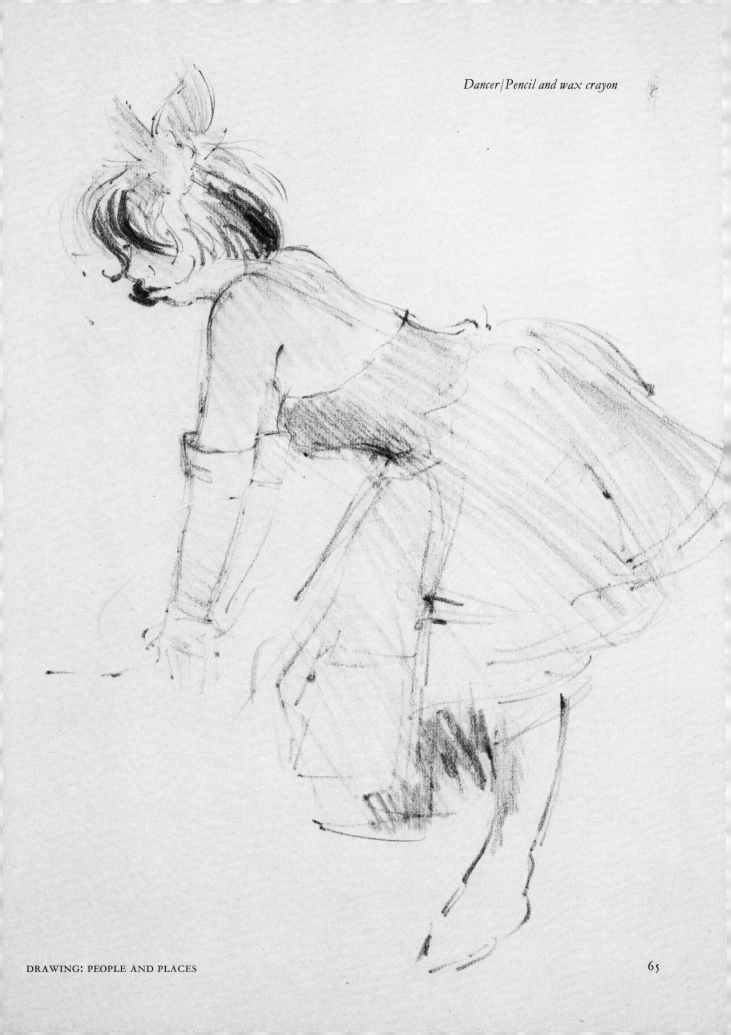

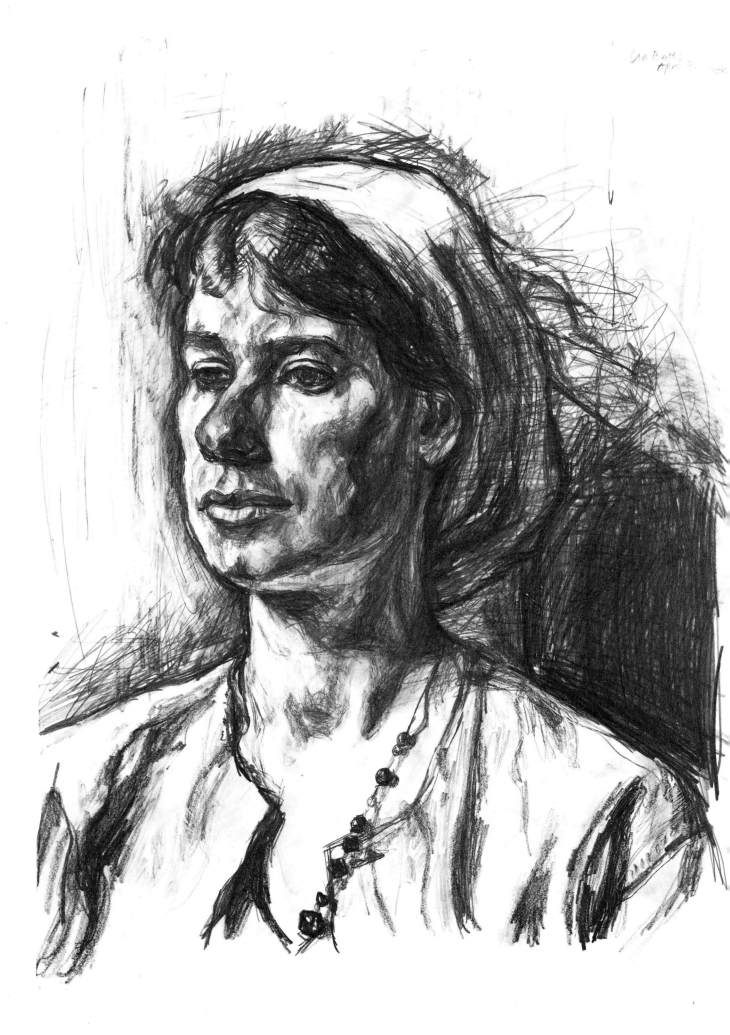

Portraits

If it is true that the artist sees more than others, then his work must reflect more than the idealism of reconstructing the face.

IN RECENT TIMES some of the most memorable portraits have been produced by photographers. The portrait by Bill Brandt of the young Robert Graves, pensively chewing the end of his pen, is the kind of image that stays in the mind. It has something to do with the fact that portraits often work best in black-and-white – the portraits by Rembrandt for instance, are essentially monochromatic. The writer Graham Greene said recently that he sees the world in black-and-white with an occasional touch of colour. Bright primary colours tend to detract from the tonal unity that is so necessary to direct one's attention towards the expression of the sitter. The expression – or film of appearance – is to some extent conceived in the mind of the artist before he begins work, for if it is true that the artist sees more than others, then his work must reflect more than the idealism of reconstructing the face.

The eyes, the ears, mouth and nose – organs of the primary senses – are visible when we draw the face. And sometimes imprinted in the expression we are able to uncover the emotional state of the sitter. 'The adventure, the great adventure' said Giacometti, 'is to see something unknown appear each day in the same face.'

Some faces are particularly interesting as subjects for drawing; the faces of writers, actors, priests and doctors for example. William Coldstream said that he was just as likely to want to paint a man because he is a doctor, as because of the shape of his head. The face of WH Auden with so many incisive lines is like a deeply etched plate of a landscape. The Jesuit priest Father D'Arcy has sat for photographers and painters alike. But the portrait by Peter Greenham in the Tate Gallery, London, is in my view among the finest produced this century.

Most portrait drawings are usually preparatory studies for paintings. It is often the case that these preliminary sketches are far more revealing than the finished work, when first impressions are sometimes compromised to achieve a likeness that will be pleasing to the sitter. 'Official' portraits these days are often no more than limp transcriptions from polaroid photographs. The best portraits are usually self-portraits, or the kind of personal studies that the artist makes of his family or friends in unguarded moments.

OPPOSITE:

Portrait/Pencil
One of two strongly expressive drawings by a young artist (*see also overleaf*) which offer an insight into the personality of the subject portrayed
SUSAN WILSON

Seated figure/Pencil
A drawing in which the contours of
the figure are barely stated, and the
expression is caught with the minimum
amount of detail

OPPOSITE:

Portrait/Pencil
SUSAN WILSON

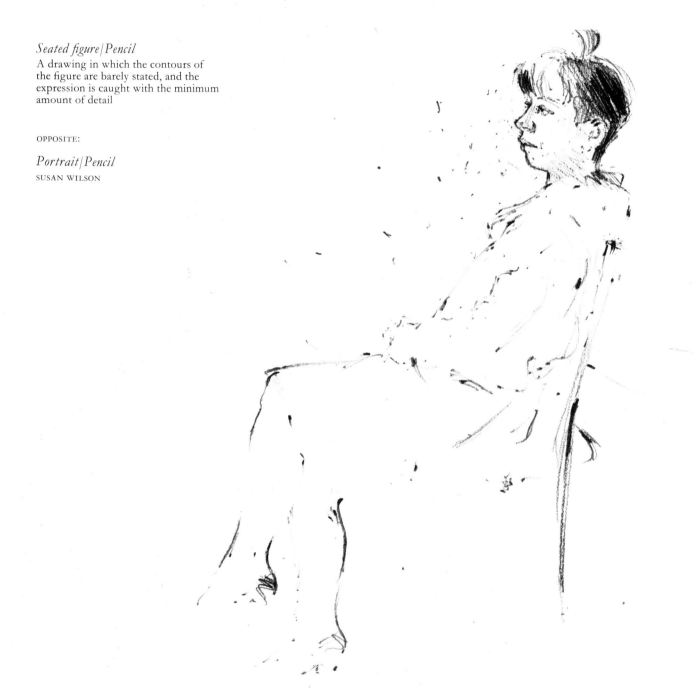

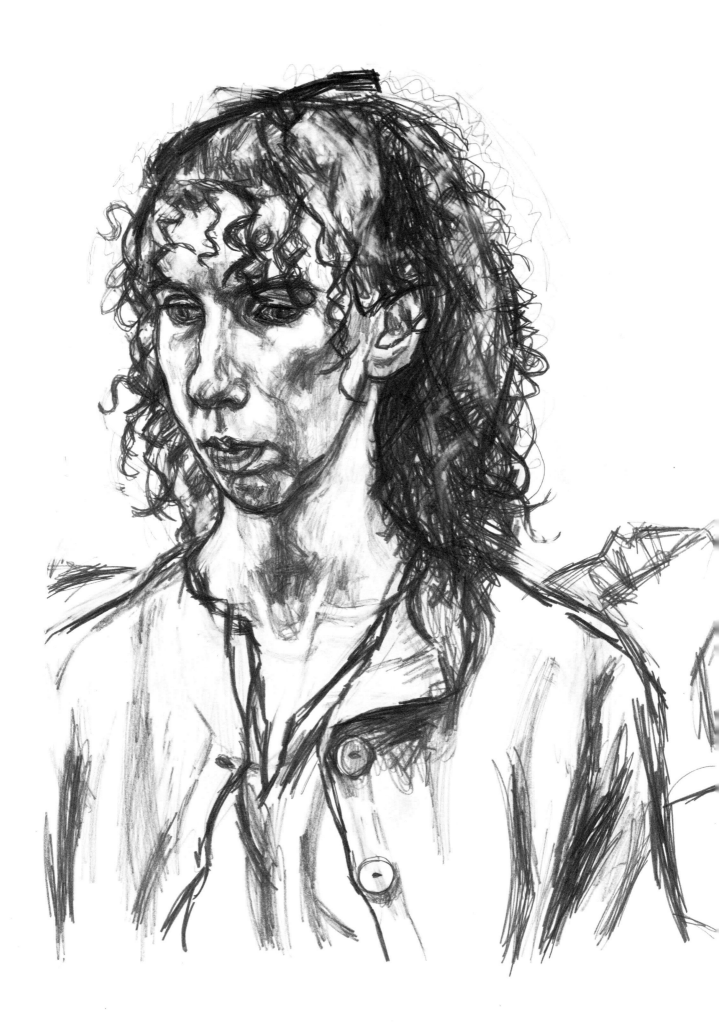

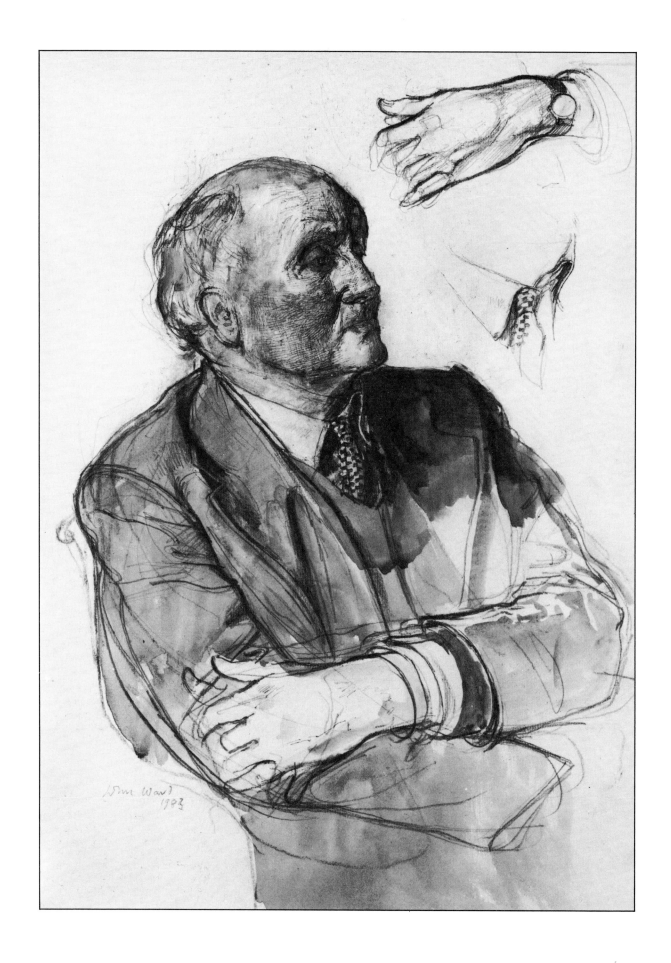

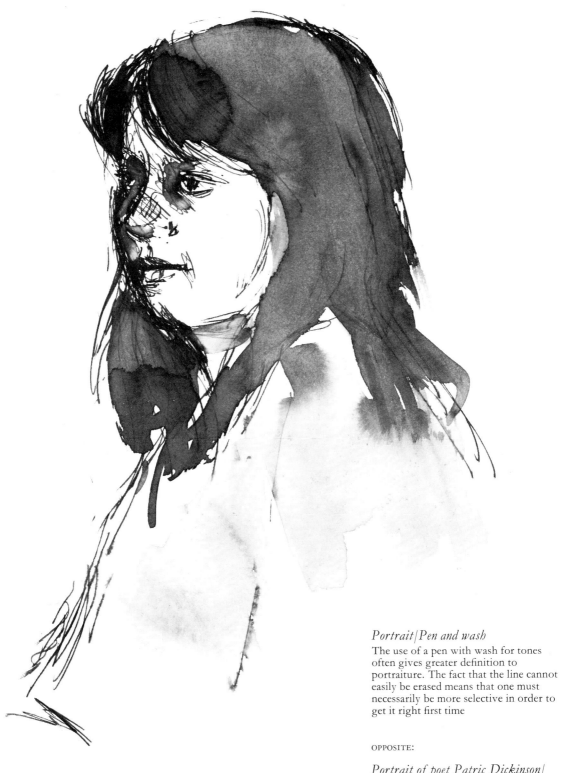

Portrait/Pen and wash

The use of a pen with wash for tones often gives greater definition to portraiture. The fact that the line cannot easily be erased means that one must necessarily be more selective in order to get it right first time

OPPOSITE:

*Portrait of poet Patric Dickinson/
Pencil and wash*

This portrait is interesting on different levels. The artist somehow manages to combine intensity and sharpness of expression with a strong rhythm in the drawing, which is akin to the lyrical quality of the poetry of his sitter
JOHN WARD CBE, RA

Portrait of artist's daughter/Pencil
ROLAND JARVIS

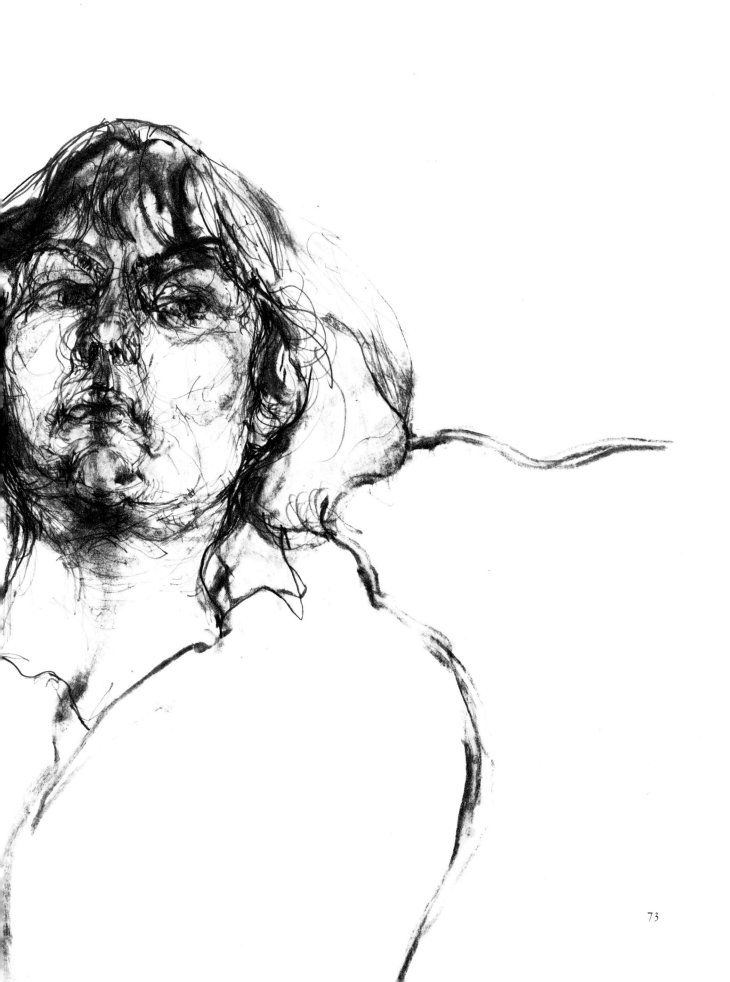

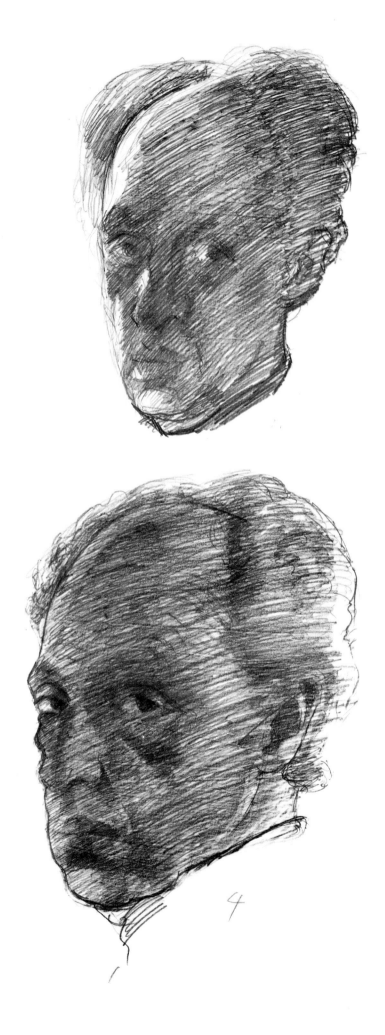

Multiple self-portrait/Pencil
HENRY INLANDER

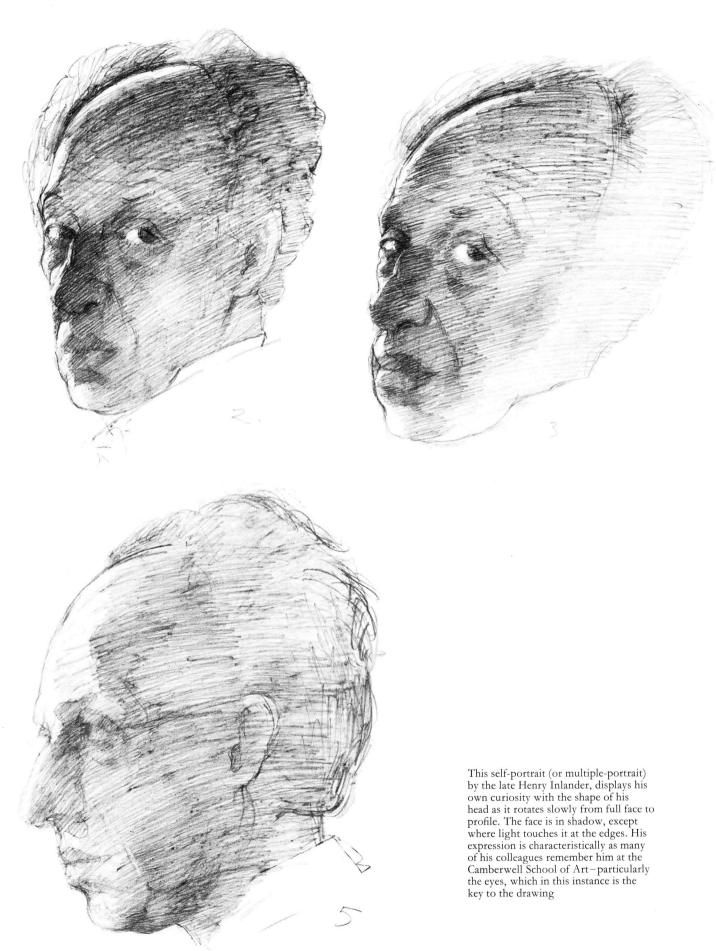

This self-portrait (or multiple-portrait) by the late Henry Inlander, displays his own curiosity with the shape of his head as it rotates slowly from full face to profile. The face is in shadow, except where light touches it at the edges. His expression is characteristically as many of his colleagues remember him at the Camberwell School of Art—particularly the eyes, which in this instance is the key to the drawing

54

Head of a young girl/Pencil and charcoal
ROLAND JARVIS

Portrait/Pencil
The only drawing in a series of short studies which succeeded in capturing the mood of the sitter

Still-life

'Just as trivial words can provide the text for a beautiful song, so trivial objects can make a perfect picture.'

BEN NICHOLSON once said that his still-life paintings were closely identified with landscape, more closely than *his* landscapes, which related more to still-life. I have always felt that still-life is a species of landscape drawing and painting. It is almost as if one were able to pick up hills, trees and hedgerows, and put them down at will in an arrangement that seems more personally satisfying. The sense of placement in the arrangement of a still-life was as important to Cézanne as the mountains, trees, monuments and figures that Poussin disposed so exquisitely in his compositions. There is a close relationship between Cézanne's still-life watercolours and his landscapes; he approached both subjects in much the same way. When one looks at successive drawings of his still-life subjects, one can see how he exchanges a green apple or pear for a red pomegranate. The front elevation of the table-top that appears bare in one drawing, is partially concealed by a cloth in the next. All the time one is aware of his strong grip on the relationship between objects and the surrounding space.

Still-life is a subject which allows us to exercise much greater control— we can select objects at will and arrange them in accordance with our own sense of rightness. Conversely, we can draw things as we find them — as Bonnard did so often with the remnants on the breakfast or lunch table.

The art historian E H Gombrich, talking about still-life, said that just as trivial words can provide the text for a beautiful song, so trivial objects can make a perfect picture. The still-life drawings, paintings and prints which Giorgio Morandi produced over many years employed the most mundane objects he could find, yet he treated them with the same significance that earlier still-life painters attached to fine silver and glass.

The design content of still-life drawing is in my view critical to the success of the drawing — all the most significant still-life works from Chardin to Cézanne have in common a strong underlying sense of design. One needs to simplify by looking for the essential structure. Still-life is perhaps the most private of all the subjects we choose to draw; one is not dependent on anyone else, nor is one at the mercy of an intemperate climate. There is ample time for contemplation, even though flowers and soft fruits will not last very long.

Although we use contour lines to describe objects and to separate them from the background, it is sometimes difficult to distinguish one from the other. This is a problem of perception which we call 'figure' and 'ground'. The viewer cannot always separate one shape from another, or

OPPOSITE:

Still-life/Pencil
CHRISTOPHER PEMBERTON

discern anything meaningful from the drawing. Experiments have shown that the perception of a contour is dependent on strong contrasting gradations of tone, and the brightness on the surface of the object in relation to the background. This phenomenon was understood very well by Cézanne, who made sure that the cone of an object nearest to the eye was left white. Patches of colour which were overlaid at the contour served to separate figure and ground, and to provide an overall unity to the composition.

The problem with still-life is that it is usually the first subject to be introduced to students learning to draw, and it is often presented in a way that seems dull. The cliché image of wine bottles, candle and fruit, dies hard and can be most uninspiring. This is a pity because many of the problems that a student encounters later on when drawing landscapes, or from the life model, can be solved whilst drawing still-life subjects. It helps to be able to draw the kind of objects one cares about. Ben Nicholson for instance, liked to draw a jug of a particular shape and design, and this image recurs time and again in his paintings and collages.

The still-life by Christopher Pemberton is anything but still. The acute sensitivity of line creates a strong sense of rhythm and movement, which recalls some of the still-life drawings by Giacometti.

The series of still-life drawings by Christopher Chamberlain reflect his exquisite sense of visual judgement. The selection and placement of objects in the room and on table-tops appeals strongly to the intellect, whereas the quality of the line and the marks he makes with charcoal possess a sensitivity which I find very satisfying. They are in my view the kind of drawings which have something to say – they demonstrate how a perceptive draughtsman can make ordinary objects seem extraordinary.

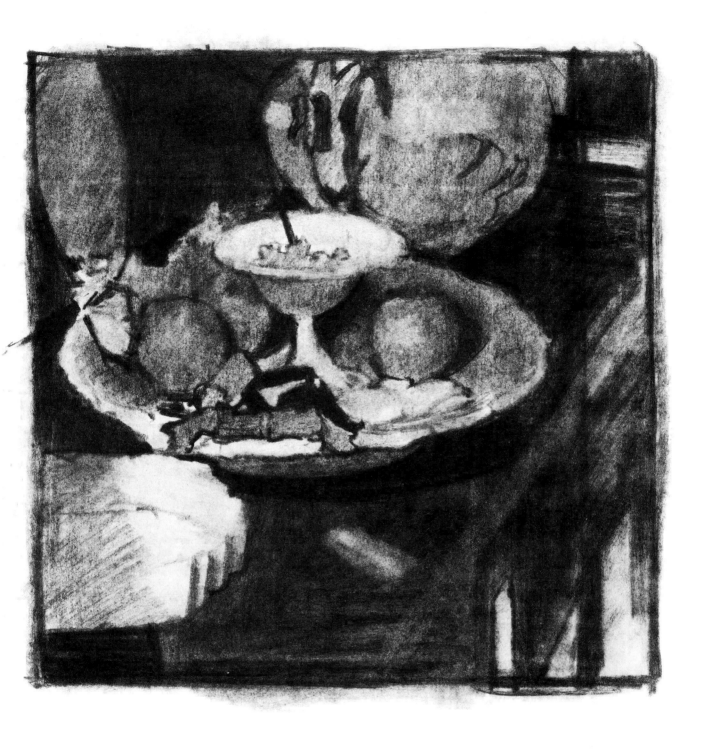

Still-life studies/Charcoal
A series of still-life studies in charcoal
on Japanese paper. The artist displays
exquisite judgement and a strong sense
of attachment to his choice of subject
CHRISTOPHER CHAMBERLAIN

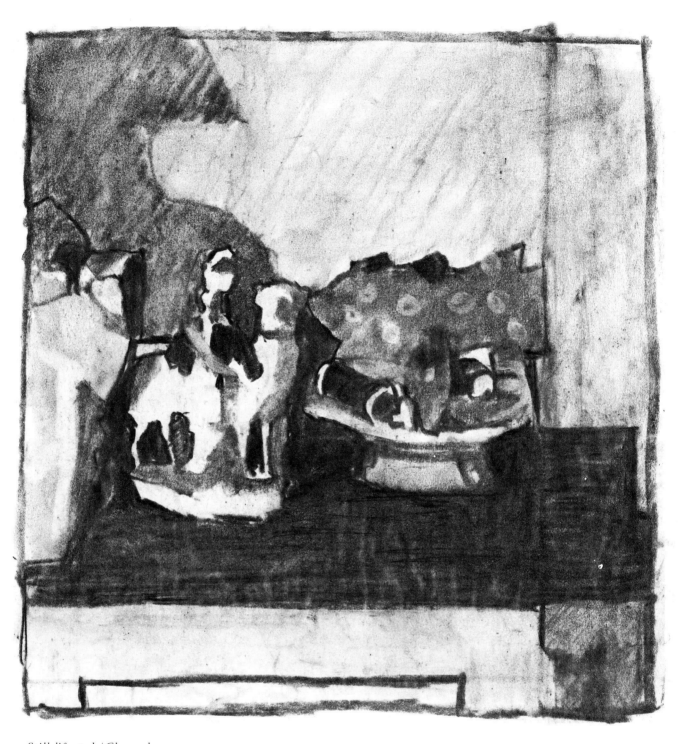

Still-life study/Charcoal
CHRISTOPHER CHAMBERLAIN

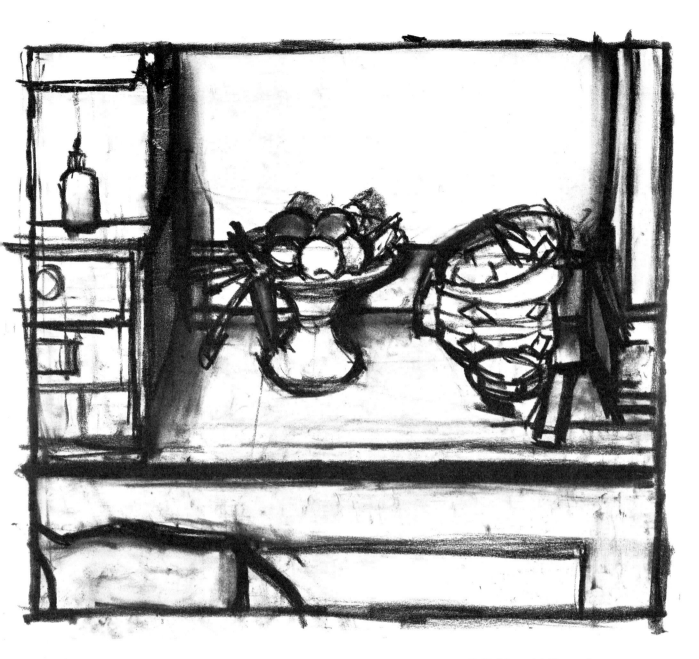

Still-life study/Charcoal
CHRISTOPHER CHAMBERLAIN

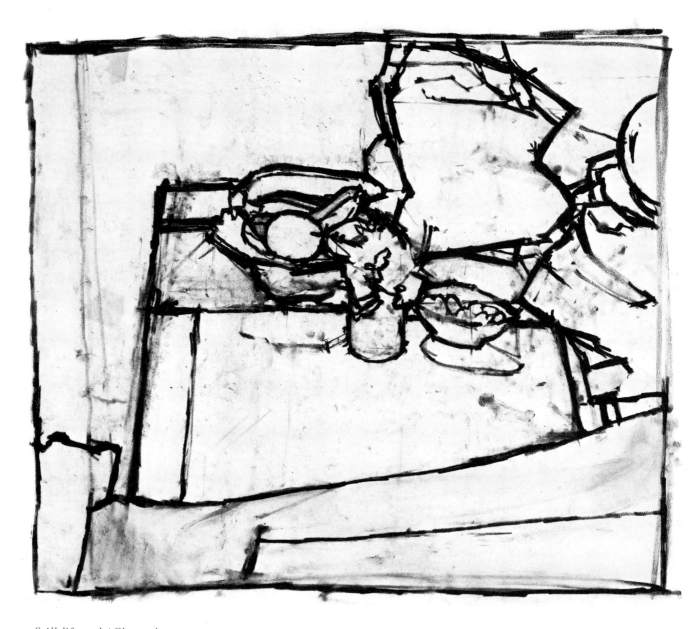

Still-life study/Charcoal
CHRISTOPHER CHAMBERLAIN

OPPOSITE:

Flowers/Pencil
The artist uses a soft pencil with an
eraser to 'carve' patches of light into
the drawing
SUSAN WILSON

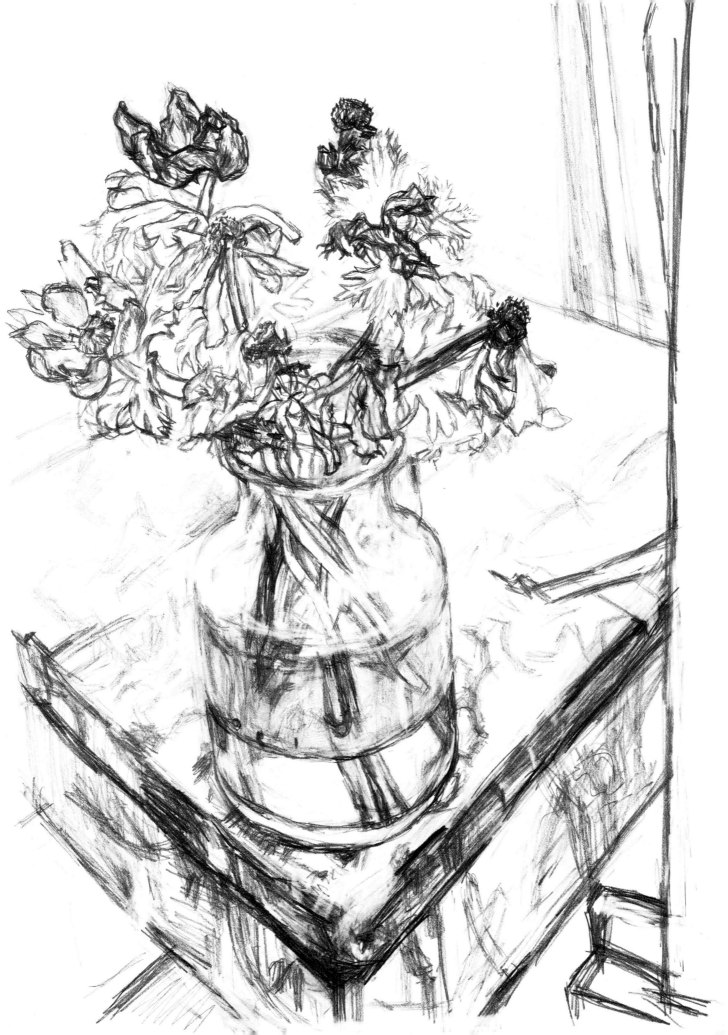

Two still-life studies/Charcoal
CHRISTOPHER CHAMBERLAIN

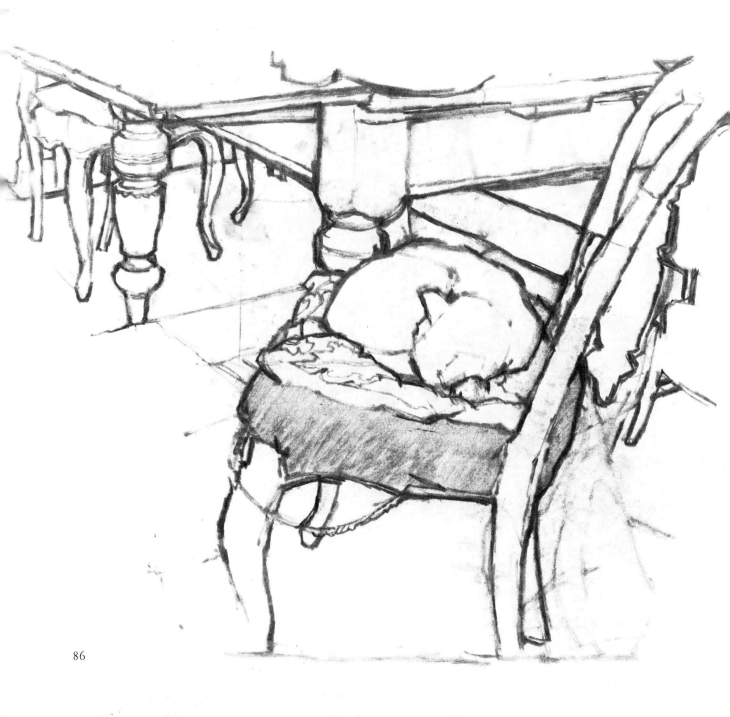

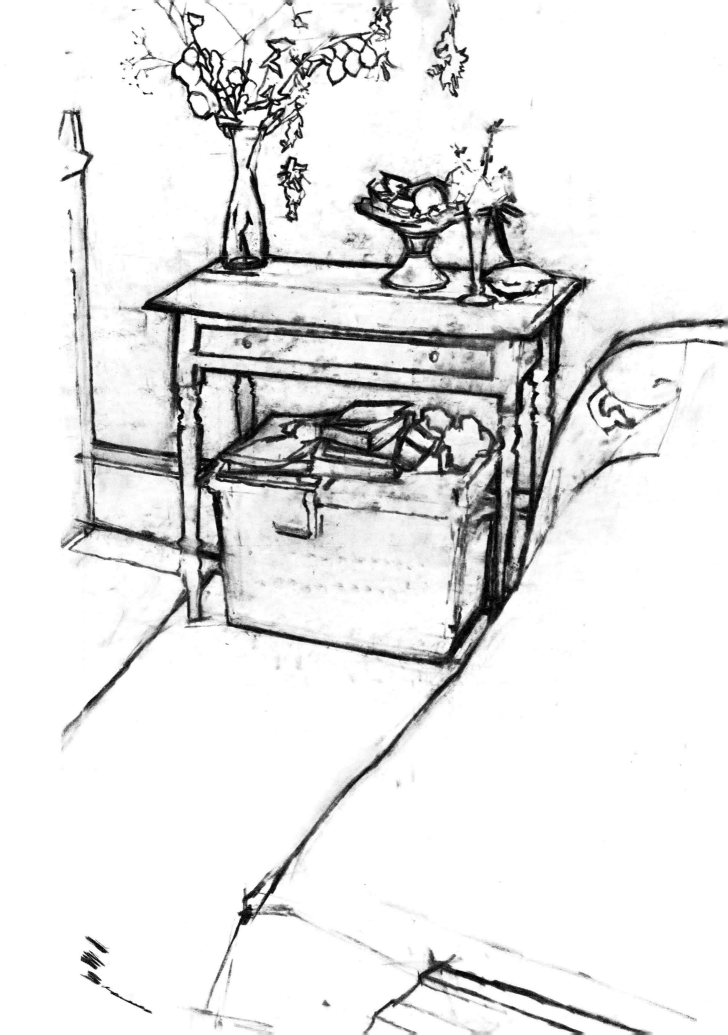

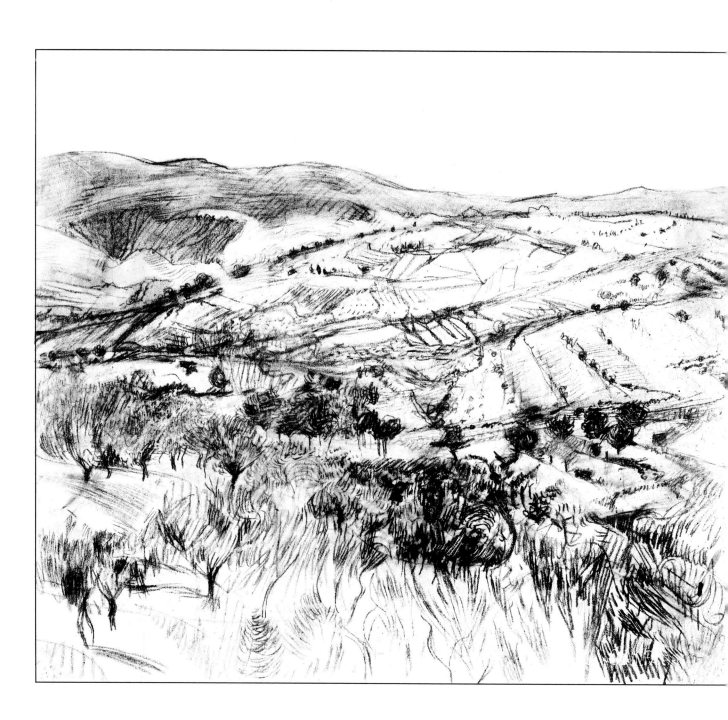

Landscape & Townscape

It is the task of the topographic artist to look beyond the picturesque, in order to uncover those things that we see but do not really perceive.

IT IS DIFFICULT to explain why one place should be more interesting than another. It has something to do with the particular relationship of parts – the way that things appear on the surface, and an inner-life which is equally important but more difficult to uncover. Places which are a source of inspiration to one artist may well alienate another; much depends on the kind of images the artist stores in his own mind. The spirit of a place is sometimes deeply absorbed in the subconscious of the individual. Giorgio de Chirico said that what the artist sees with his eyes open is important, but what he sees with his eyes shut is even more important. The poet Gerard Manley Hopkins introduced the word 'inscape' into the language to suggest the way in which the things that one perceives externally, correspond to one's inner feelings about the character of a place. Turner, one of the greatest topographic artists, used sometimes to include mountains in his compositions, even when none could be seen.

To truly know a place it is necessary to search beyond the physical and geological features described in guidebooks. There are other elements, which when revealed can arouse in us previously undisturbed emotions. It is the task of the topographical artist to look beyond the picturesque, in order to uncover those things that we see but do not really perceive. In the best landscape drawings the artist usually demonstrates a close affinity with the place he is drawing, and uses line with a peculiar force to suggest a distinctive presence. The main body of an artist's or writer's work can sometimes be linked to a particular region or location; it is the kind of association which develops gradually over a number of years. One must be patient, and be prepared to wait perhaps for a long time before a landscape will yield up its secrets.

There is a temptation to make drawings in well-tried locations which may have induced fine work from those artists whom we admire and respect. But this might lead only to frustration and creative impasse. I remember for example, staying in Aix-en-Provence some years ago, and walking through the nearby forest of Tholonet where Cézanne produced so many of his direct studies from nature. Although I had all the necessary materials with me I found that I just could not bring myself to draw anything at all. Everywhere I looked I saw the landscape through the eyes of Cézanne – the vibrant green needles of the Parasol pines contrasting with the rich red earth, and in the distance the Mont Ste Victoire. I moved on eventually to the neighbouring town of Gardanne, where the red earth

OPPOSITE:

Landscape, Tuscany/Soft pencil on toned paper
The wide range of marks made by the artist almost suggests colour
HENRY INLANDER

that Cézanne had painted is quarried locally for the mineral Bauxite, which is used in the production of aluminium. The relationship between the industrial processing plant and the surrounding landscape did have a particular appeal, and motivated me sufficiently to want to start drawing. The point being of course that it was a relationship between parts that I had discovered for myself, and not through the eyes of another artist.

Landscape drawing is essentially about the art of relationships. The artist sees everything in terms of his own emotional response to a place – he regroups all the various elements before him. He observes the particular disposition of buildings, trees, bridges, rivers and so on, and puts them together in his drawing in such a way that a kind of drama is released. By describing in his work the emotion that he attaches to specific objects, he can sometimes say much more about the spirit of a place than a photographer ever can. Ben Nicholson once said, 'When I draw Siena cathedral it is not the stones I am drawing, but the feeling.'

I often find the most interesting buildings to draw are those that belong to the functional tradition of industrial architecture – barns, warehouses, silos, factories and so on. Those buildings used for agricultural purposes are often made from local materials, and are easily assimilated into the landscape. Alternatively, materials with strongly contrasting colours and textures are employed – I particularly like a flint barn near where I live which has a bright red corrugated iron roof. I am also attracted by the incongruous relationship between man-made industrial artefacts and landscape. Dungeness, on the coast of Kent, is one of my favourite haunts. It stands on a flat promontory of reclaimed land that reaches out into the English Channel. There is a fishing community where every dwelling is different – from rough black tarred shacks, and bungalows reconstructed from disused railway carriages, to a primitive version of 'fisherman's Gothic'. There are trawlers with all the associated paraphernalia of winches and storage sheds, two lighthouses, a nuclear power station, a bird sanctuary, a military firing range, a sand quarry, a lifeboat station, the world's smallest commercial railway, and a number of structures whose function for me remains a complete mystery. In winter it is bitterly cold and I am only able to draw for short periods of time. Even in summer there are dense sea fogs which can descend suddenly. But there are days when there is a great clarity of light and the shingles are feathered with reeds and orange sea poppies, and the superb remoteness of the place makes it unlike anywhere else I know. Further inland the Romney Marsh also has a distinctive character. It is a marshland rich in sheep pasture punctuated by primitive stone churches flanked by dykes and willows.

→ *page 94*

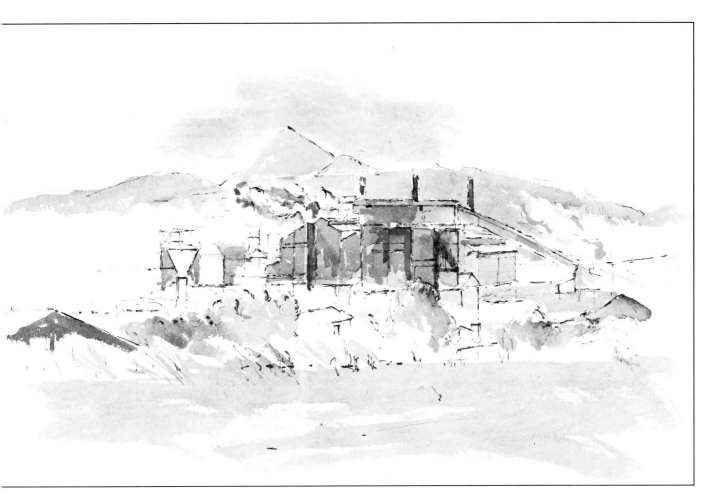

Bauxite processing plant at Gardanne,
France/Pencil and watercolour

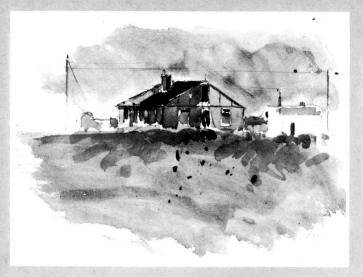

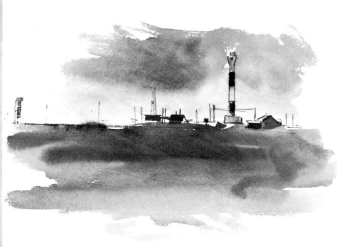

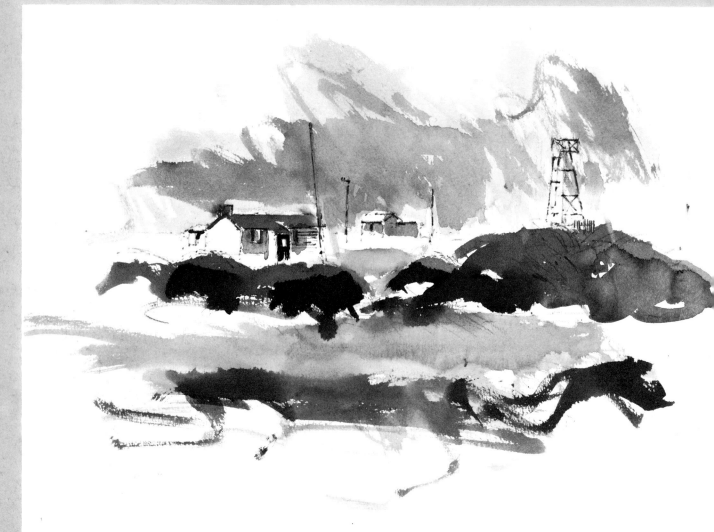

Dungeness, Kent/Pencil and watercolour

There is a sense of desolation in this
series of drawings which is heightened
by the presence of itinerant makeshift
houses

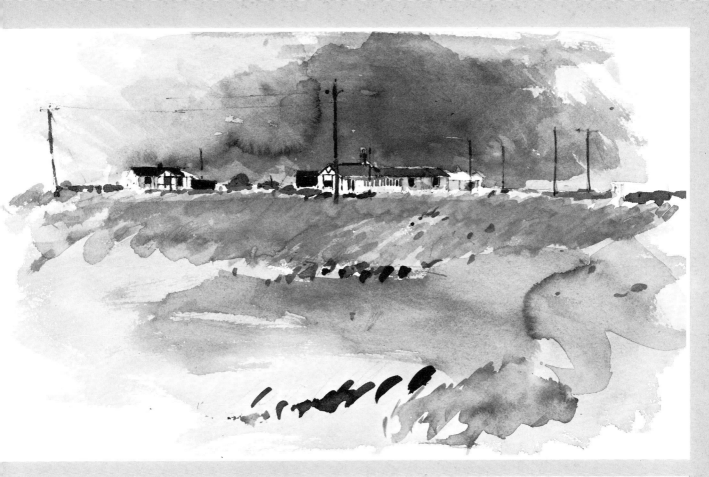

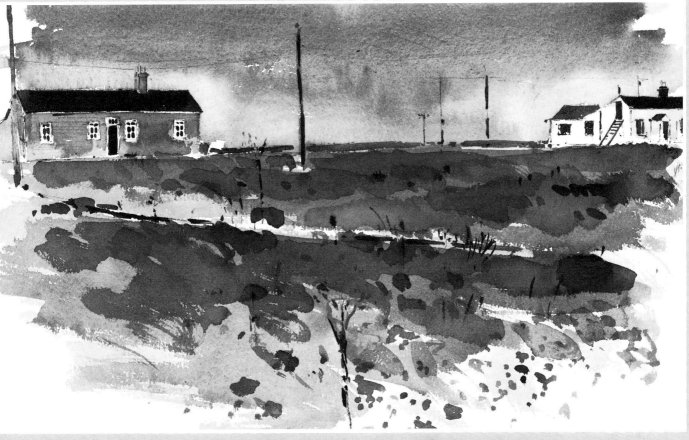

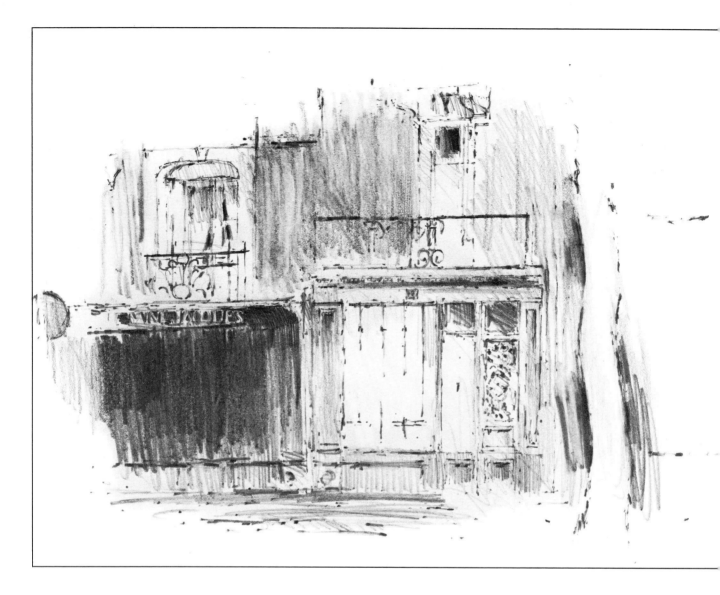

Shopfronts in Dieppe/Pencil
The old shopfronts are rapidly being
replaced by anodised aluminium

I usually look for landscape subjects where there is some kind of
incident – where there is some feature which significantly transforms an
otherwise indeterminate scene. The reasons for this may well have some-
thing to do with the fact that I spent my childhood near Ironbridge in
England – the birthplace of the industrial revolution. The remnants of
those early industries have now become ageing monuments amongst the
foliage of the Severn Gorge. The particular placement of ironworks,
bridges and kilns in relation to the river and terraces of workers' cottages,
was very atmospheric. When I went back recently however, much of the
atmosphere had been destroyed by an over-zealous programme of con-
servation.

I am not suggesting that such places should be maintained in a
permanent state of decay – that would be inexcusably sentimental. But
what has gone cannot be replaced, and the artist is constantly having
to adapt to new environments and new relationships which are part of
a continuum between man-made structures and the natural world. It
is important to remember that one is concerned with the *appearance* of
things – an electricity pylon which might offend someone who is an ardent
conservationist, might prove to be a useful compositional device to some-
one who is producing a drawing.

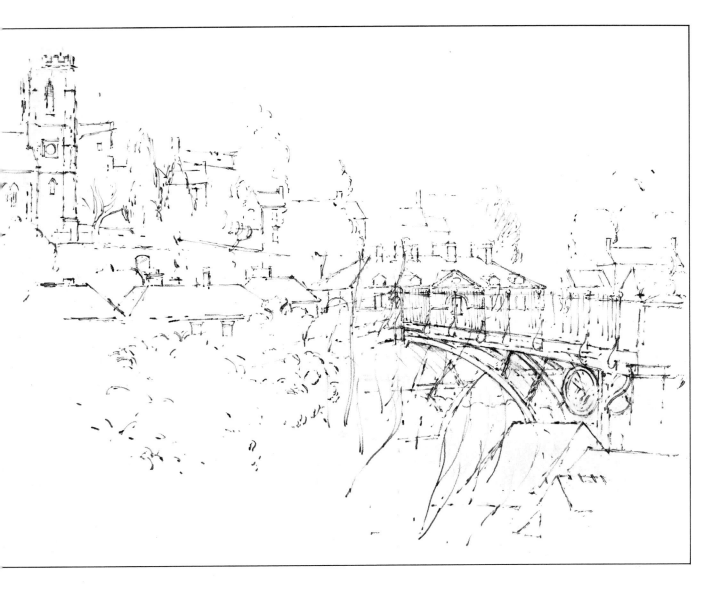

Ironbridge, Shropshire/Pencil
It was difficult to concentrate on this drawing because of frequent squalls of heavy rain. I tried to register the main forms and create a sense of unity even though much detail is left out. There is an interesting visual relationship between the structure of the bridge and the terraced buildings on the steep banks of the Severn Gorge

If the over-familiarity of a place begins to dull the senses, it is sometimes necessary to seek a complete change of scene. The short stretch of sea that divides England from France for instance, also separates two cultures which are visually very different. Dieppe is for me the most endearing of the channel ports. It has a completeness; the feeling of a working community still intact. It is an enchanting place which can inspire a kind of tranquil sadness. The part I like best is that small square between the church of St Jacques and the Rue St Catherine, where it always seems to be spring or summer. To sit there drawing inconspicuously for an hour or so is to invite a contentment I have rarely experienced elsewhere. It was in Dieppe that Walter Richard Sickert discovered for himself the laws of harmony – 'The colour in the shadows must be the sister of the colour in the light.' Sombre atmospheric hues contrast sharply with brightly painted shopfronts – pink and vermilion against dark grey-greens, ultramarine and cobalt, separated by time-darkened shades of brick and plaster. The bright red shopfront that Sickert painted in Dieppe which he called 'October Sun', is the reddest thing I have ever seen. And when one departs from a place like Dieppe one tends to remember fragments and details, rather than a complete scene. A house number crudely stencilled on a stone doorway, a torn circus poster, a face seen for a second in the

→ *page 101*

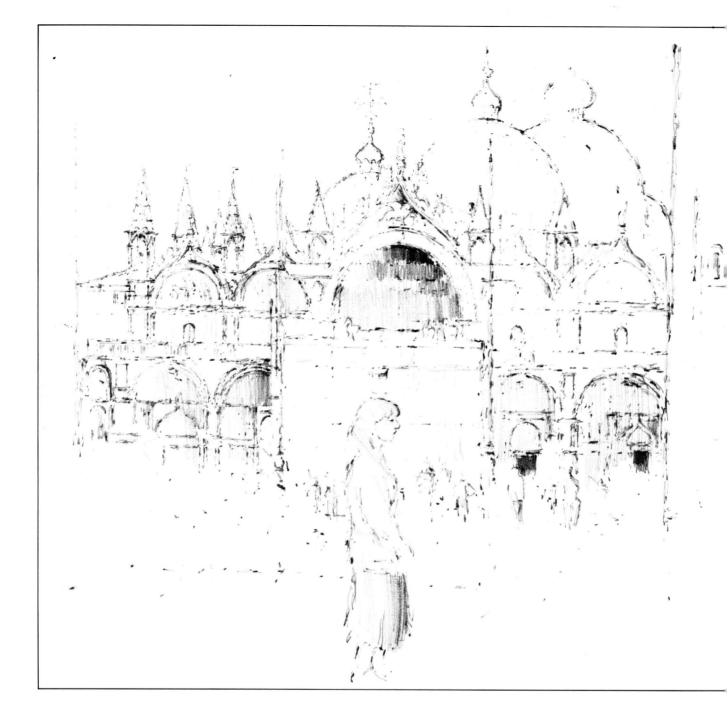

*Three studies of Venice/Pencil and
watercolour*

These drawings were made on a three-
day visit to Venice at the height of the
tourist season. A problem with Venice is
that although there is so much to draw,
access is quite difficult. I had to draw
with dozens of tourists milling around
so that one becomes just another curiosity
on the tourist itinerary – which makes
concentration difficult

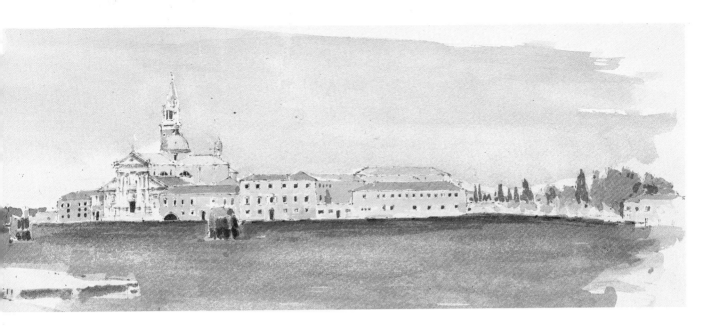

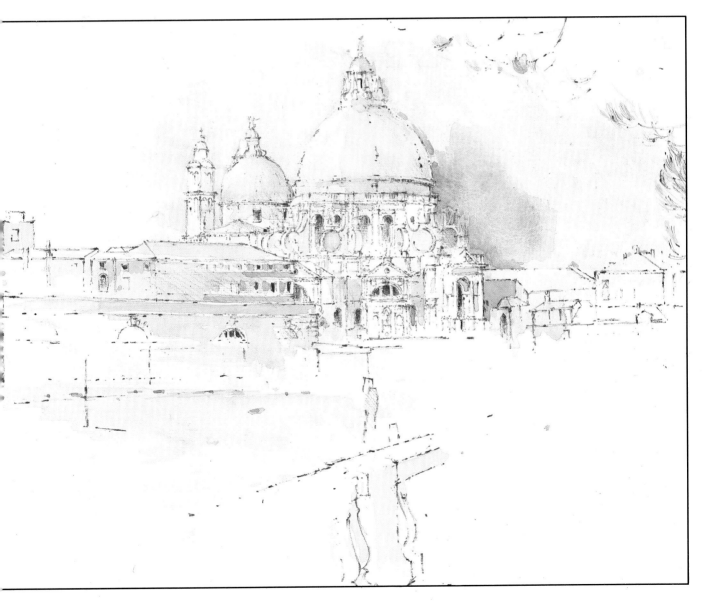

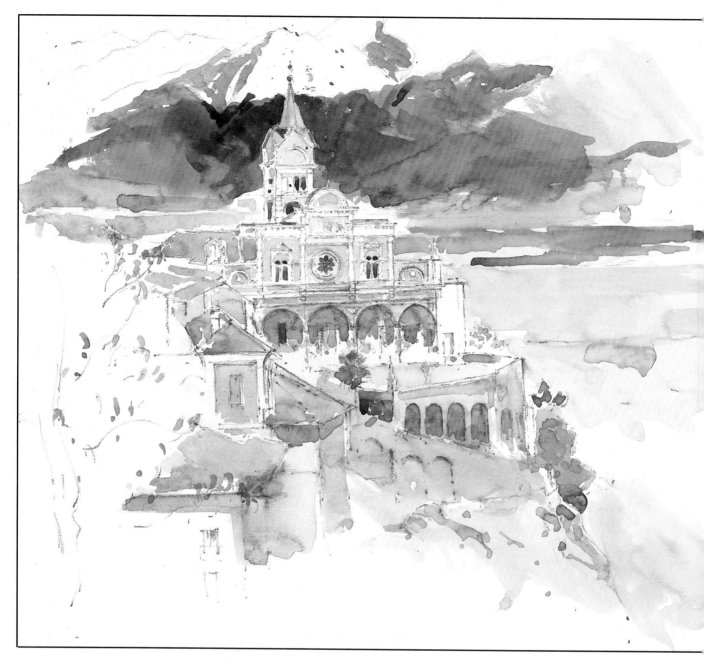

Madonna del Sasso, Locarno, Switzerland/Pencil and watercolour
This drawing was produced on a bright day in early spring. The distinctive ochre stucco of the church and the spectacular setting 355 metres above lago Maggiore, is seen against the backdrop of the snow covered mountains of the Ticino

OPPOSITE: ABOVE

Sion, Switzerland/Pencil and watercolour
The town of Sion is 2000 years old. The two dramatic peaks of Valere and Tourbillon are each crowned with episcopal fortresses. I had to work quickly against failing light, but in a short space of time managed to evoke something of the atmospheric qualities of the site

BELOW

San Gimignano early morning/Brush and watercolour
This painting was produced at first light from the balcony of my hotel bedroom. The mist rises slowly, changing from a silhouette almost in monochrome to the gradual emergence of full colour

DRAWING: LANDSCAPE AND TOWNSCAPE

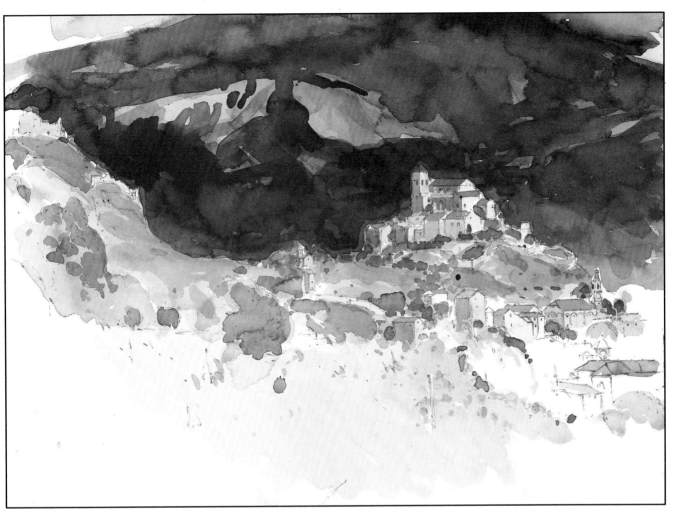

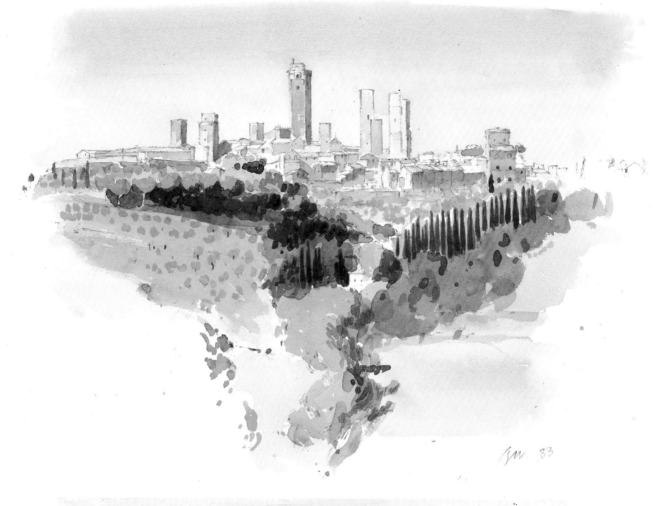

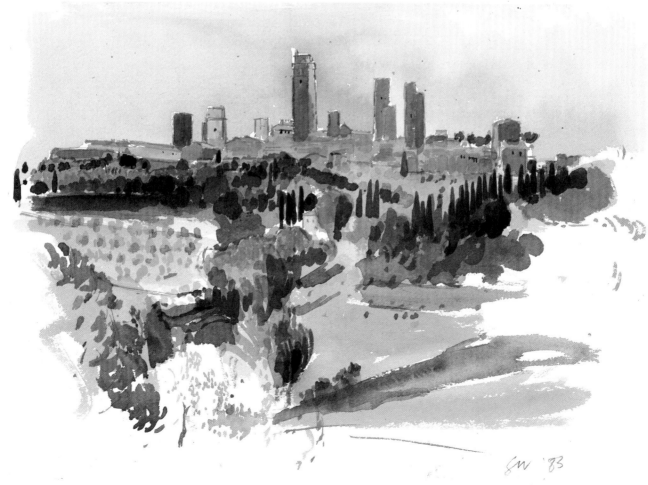

darker recesses of the arcades—to admit such detail into one's subconscious is to come closer to truly knowing a place.

Artists today are prepared to travel to quite distant countries in search of new subject matter. For myself I feel there is still much to discover in my own country, and in mainland Europe. Italy is a country I visit frequently. It has inspired generations of English artists, writers and poets. Essentially it represents the classical ideal—fine architecture set in a landscape of vine, cypress and olive. But even in the more industrial cities of Turin, Genoa and Milan there is a visual excitement which I find very stimulating.

Hilltowns often have a spectacular setting; San Gimignano perched high on a Tuscan hill between Florence and Siena is the kind of place which induces me to draw. I remember my first visit; it was in October, still very hot and the time of the grape harvest, or 'Vendemmia'. The bus took a lazy hour or so along narrow dusty roads from Florence, but the tall stone towers which are a feature of the city were visible long before the bus arrived. When I finally entered the city gate I felt a sense of elation in having discovered a place where I knew instinctively I would find subjects to interest me. I produced three drawings in the few hours I spent there on that first visit, and I have been back many times since. The surrounding landscape is so rich in colour, shape and contour, that it is difficult to limit my drawings to monochrome. The ochres and browns of the hills, dark black candles of cypress, and the silvered viridian of olive leaves when trapped by sunlight, cannot adequately be described without some hint of colour.

Drawing outside presents its own problems, and the success or failure of a drawing might depend on a number of factors. There are times in some moods when I can't seem to put a foot right, and other times when everything seems to work together. Climate has a bearing on everything; it may be too hot, or too cold, or very windy, or the light may be too level and without contrast. One's presence of mind might be upset by something quite simple like having the wrong type of pencil, or sitting or standing in an awkward position. Quite recently I was doing a series of drawings in and around the city of Avignon. It was early spring, and a strong cold wind was being tunnelled down the Rhone valley. Although I thought I was suitably dressed in warm clothing, I became so absorbed in my work that the prolonged exposure to cold made me very ill indeed. Perhaps we sometimes expect too much of ourselves. It is best to start without hoping for too much, and then just occasionally something reasonably satisfying might emerge. I remember the late Vivian Pitchforth once

→ page 106

The towers of San Gimignano, Tuscany/Pencil and watercolour
Two studies—a morning study with the towers in sunlight, and an afternoon study from the same site when the towers were in shadow

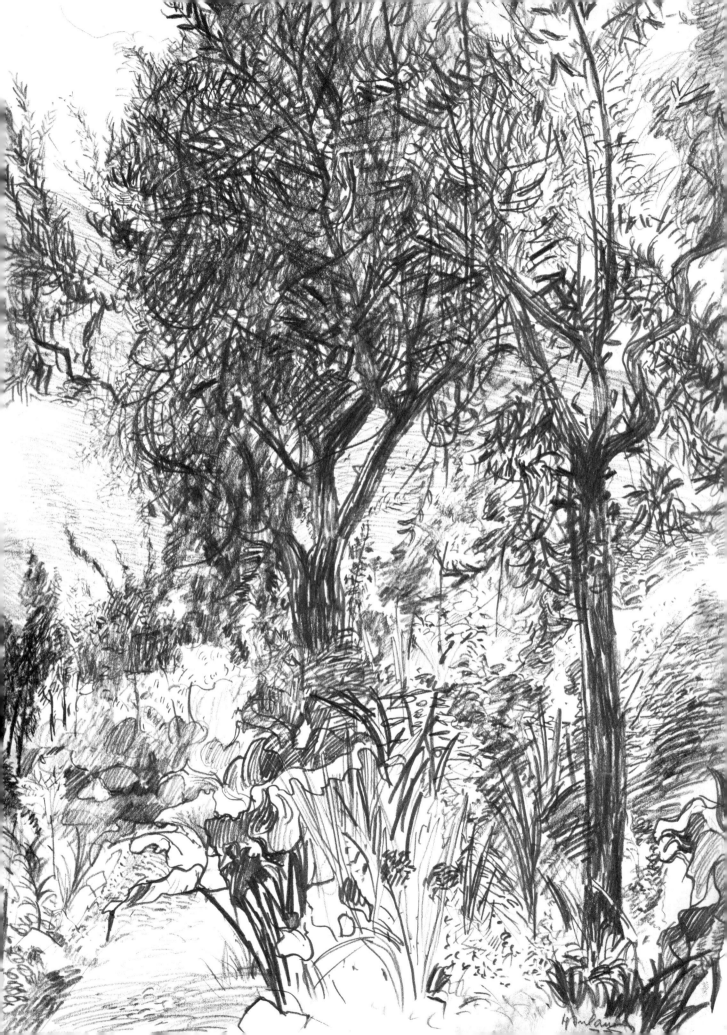

Woodland scene/Charcoal
This drawing is full of delicacy with a
feeling for light
ROGER DE GREY PRA

OPPOSITE:

Olive grove/Pencil
A pencil drawing with a wide variety of
tone and texture
HENRY INLANDER

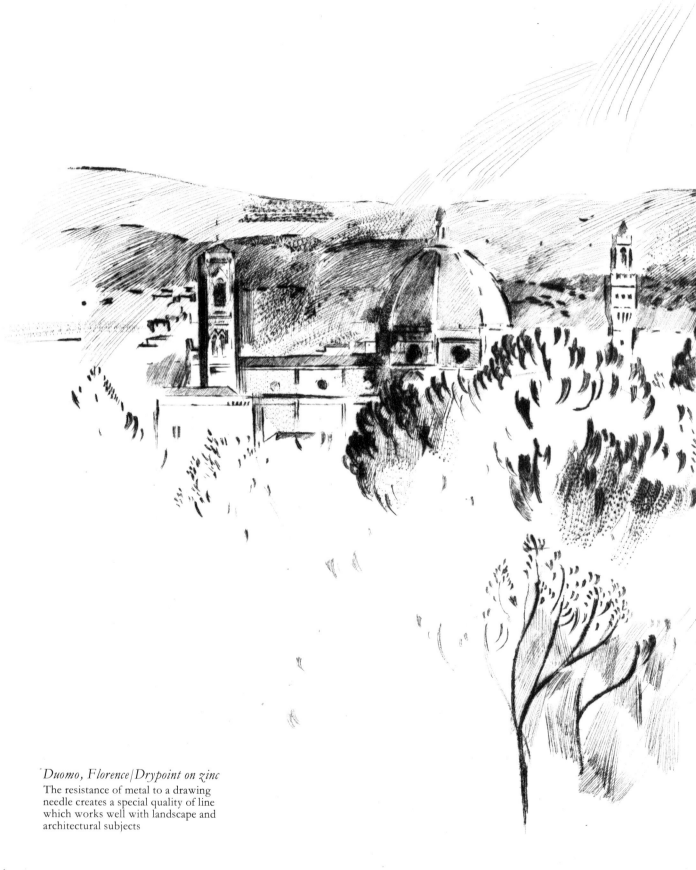

Duomo, Florence/Drypoint on zinc
The resistance of metal to a drawing
needle creates a special quality of line
which works well with landscape and
architectural subjects

6/25

Duomo

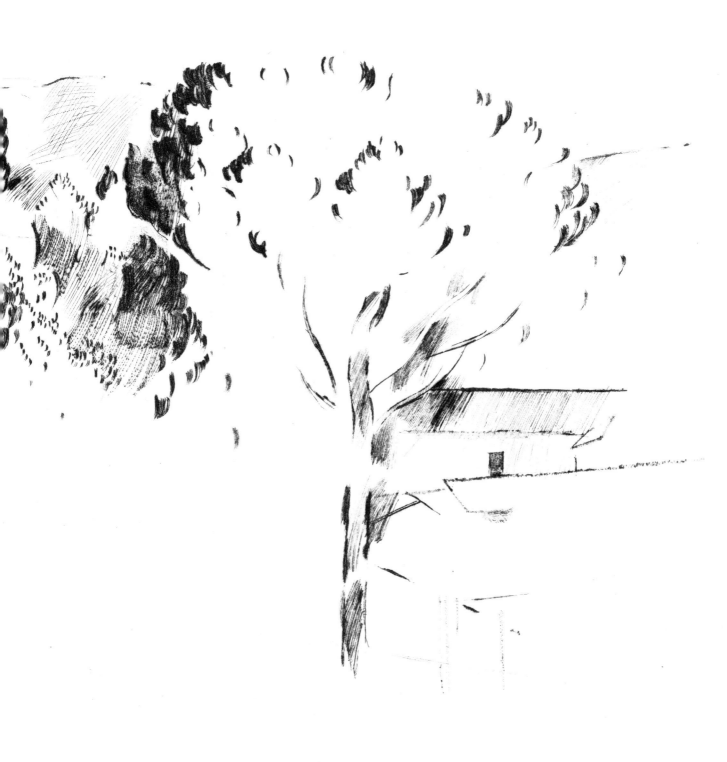

telling me that if he went to Italy and did a hundred drawings, he was sure to come back with *one* that would be all right.

In landscape there is usually greater depth than there is breadth, and we cope with this tonally by making the drawing lighter as planes recede. When for example, about to draw a building on a hilltop which might be four or five miles distant, the draughtsman can from any point project himself into the most distant plane, and pick out isolated objects.

I know from my own experience that if I take a photograph of a subject that I have drawn, the drawing often carries more information than the resulting photograph where everything seems lost in diminutive detail. One needs to be acutely aware of the way in which the same subject can appear under varying conditions of light, at different times of day, and in different seasons. It is not always necessary to work in strong sunlight; some subjects are more atmospheric at first light, or at dusk. I sometimes wonder if it is generally realised just how much time an artist might spend in searching for the subject, for the right viewpoint – and then waiting for the most suitable conditions of light. It is important to remember when working outside that to represent colour in monochrome, or even to match the colour itself, one can only do so as one sees that colour in a particular situation, and under a certain quality of light. All of which means that it might well be difficult to continue working the following day without making radical adjustments to tone and colour.

To sit in an olive grove in warm sunlight with pencil and paper is a pleasant enough experience, regardless of how the drawing or painting might eventually turn out. But to begin drawing in the centre of a hot, crowded city, is something quite different. I shall always be grateful to the tutor who, in my early art school training, insisted that I should make drawings inside a busy Woolworth's store – it is a stultifying experience!

Drawing in public places calls for a special kind of resilience and self-discipline. And yet the tension created in such circumstances can stimulate one to produce drawings of the kind that might not develop in a more relaxed situation. One building isolated in a landscape can be experienced as architecture, but when one enters a town or city, then one is less conscious of architectural qualities than the kind of atmosphere that is created by the compression of a great many buildings together. Cities have their own particular visual excitement. The variety of architectural styles, changes of level, and structures that project and recede, the totality of which stirs the imagination – when suddenly one turns a corner to discover an unsuspected view. For an artist there is always a kind of anticipatory pleasure in walking through a city for the first time.

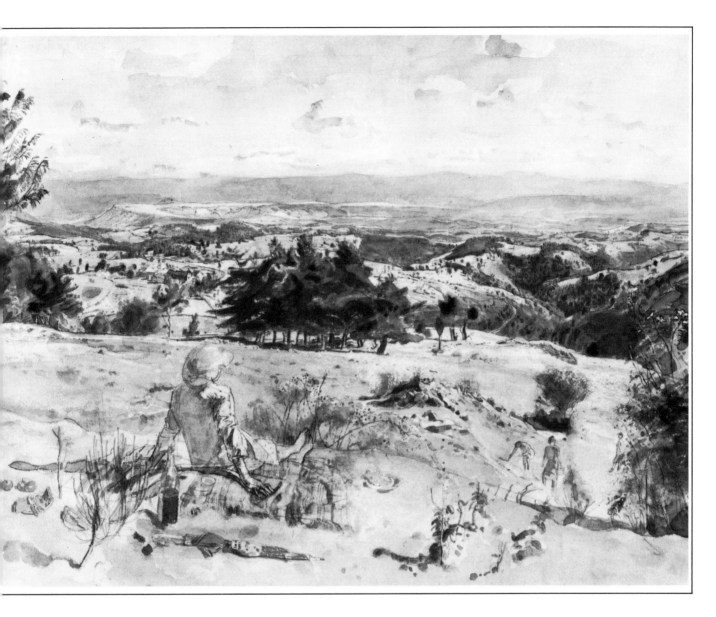

Alison in the Auvergne/Pencil and watercolour
JOHN WARD CBE, RA

Nostalgia is often the moving force behind townscape drawings, the remnants of some bygone era – street markets, old shopfronts, theatres and cinemas; every city has its own particular features, its own flavour. The unexpected mingling of solid and forthright buildings of the 19th century with the cool brutalism of contemporary architecture, produces contrasts which can be dramatic. I find that in many industrial cities the commercial buildings, and factories with their strong functional simplicity, can be just as interesting visually as the vernacular religious and domestic architecture of earlier periods. In England for example, I am more likely to find subjects which will induce me to draw in Liverpool or Gravesend, than I would in Bath or Cheltenham. But then conversely, another artist might find the particular setting of the Pulteney Bridge in Bath or the Regency terraces of Cheltenham equally rewarding.

Composition

If the quality of a drawn line tells us something about the emotions of the artist who made it, then the way a drawing is composed also tells us a little about his intellect. When we look at the classical compositions of Lorraine or Poussin, we are aware of a special kind of intelligence at work which is released through exquisite visual judgement.

Composition is really about using one's sense of visual judgement to create order – arranging the various elements that make up a scene in such a way that there is an interaction between parts of the drawing. William Coldstream once said that as soon as he had started to paint he became mainly occupied with putting things in the right place. The seemingly technical aspect of composition and perspective can often seem daunting – especially for those artists – who, like myself, have only a perfunctory interest in mathematical formulae. Historians I feel sometimes make too much of the artist's reliance on geometry as a means of dividing the picture plane. The more one draws, the more one is better able to make judgements about composition empirically. I prefer to rely on my own sense of the rightness of the way elements are disposed in a drawing, rather than be bound by predetermined mathematical equations. It often happens however, that the most significant vertical structure in a drawing I have made coincides with the division I would have arrived at by using the Golden Section.

At the time of making a drawing I am not conscious of any kind of compositional formula; I simply place things intuitively as I judge them to be right. Equally when I am drawing a church, or a bridge, or some other structure, I am merely drawing things as I see them. The fact that

→ page 114

DRAWING: LANDSCAPE AND TOWNSCAPE

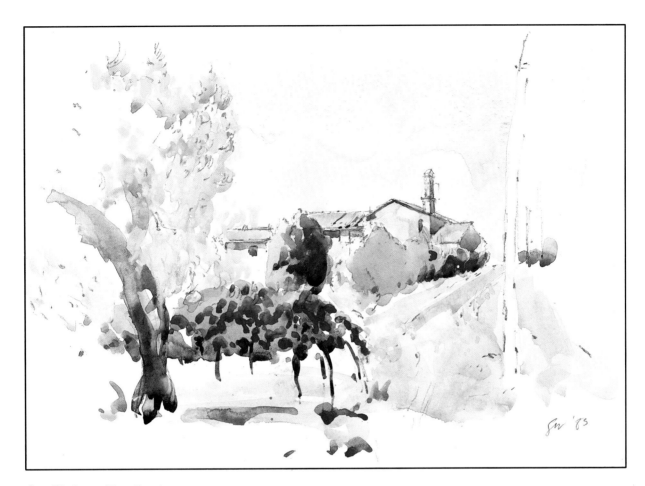

*San Gimignano/Pencil and
watercolour*
This is a drawing made rapidly
under intense sunlight at mid-day

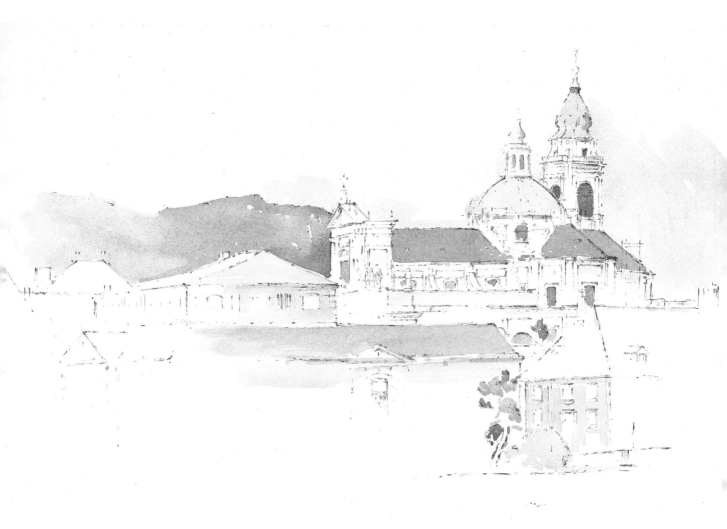

Cathedral of St Ursus, Solothurn,
Switzerland/Pencil and watercolour
A baroque church at the foot of the Jura
mountains. This is a drawing which
relies on the artist's ability to be
selective when confronted by a great
deal of architectural and other detail

OPPOSITE: ABOVE

St Croce, Florence/Pencil and
watercolour
A drawing made towards dusk when
there is less contrast and colours are
more muted

BELOW

St David's Cathedral, Wales/Pencil
and watercolour
The cathedral and ruins are interesting
from different viewpoints. The
surrounding landscape is craggy and
full of variety. The number of washes
were restricted in order to unify the
tones in this painting, without losing the
feeling for the particular quality of light

DRAWING: LANDSCAPE AND TOWNSCAPE

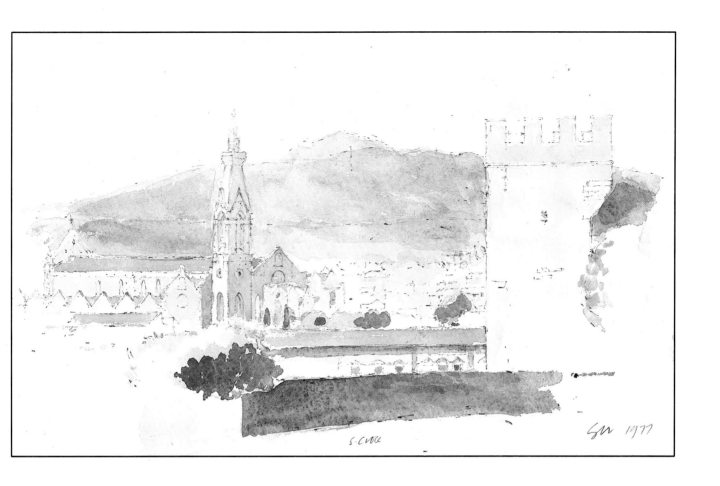

S·Croce

GW 1977

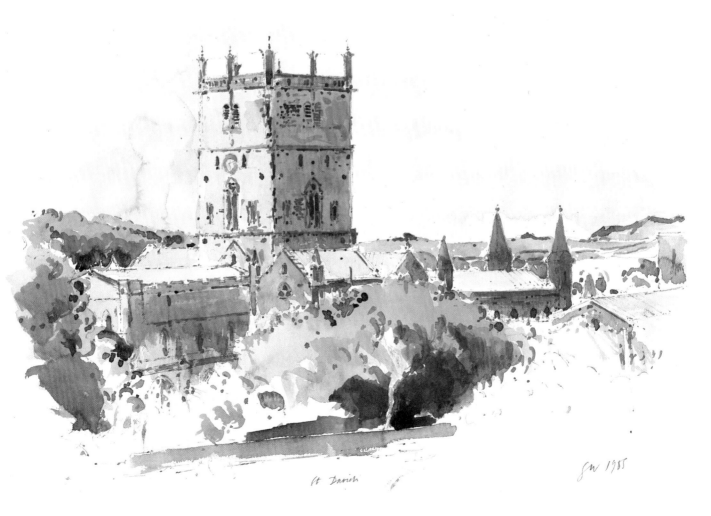

St Davids

GW 1985

*Farm buildings/Pencil and
watercolour*
The farms in central Switzerland
(*top left*) are characterised by low barns
with rich red-tiled roofs.
Sussex barns make use of flint and are
more easily assimilated into the landscape

the resulting drawing appears to work in terms of perspective is due to the amount of concentration that has gone into the way I perceive one angle in relation to another.

Impressionism displaced the classical notions of composition, and photography has also conditioned us to accept a less formal arrangement in the way drawings and paintings are composed. The indeterminate aspect of landscape however, does require that we become selective, and one's ability to make judgements about relationships is helped by an awareness of compositional values. Of a total scene in view it is possible to cope with only a comparatively small area. It takes time to actually establish in a drawing the main underlying structure; some things are unstable, others are in movement and there is a need to fix on specific nodal points against which one can then sort out the conjunctive shapes of things. Cézanne's dictum that everything in nature is modelled on the sphere, the cylinder and the cone becomes obvious when one starts to analyse the basic forms in nature. But the same basic shapes are repeated a great many times, sometimes overlapping one another, sometimes half hidden and difficult to substantiate.

When the main structure of the composition has been established, one needs to be aware of the way that interlocking planes and shapes are linked together by contrasting tones of light and shadow. There are some artists who make constant use of compositional devices such as paths, roads and rivers, which are intended to lead the eye from the foreground towards the most significant part of the drawing. Similarly, dynamic shapes might be contrasted with static shapes and so on. But we should be careful not to use such conventions in a contrived way—most of the forms that one sees in nature are too interesting and varied to be utilised in some preconceived plan. The compositional possibilities should emerge from the things we see each time we analyse a particular scene, so that we avoid any tendency towards artificiality.

When working in watercolour it is not always necessary to work from edge to edge, or corner to corner of the paper simply to fill all the space. The white of the paper might itself be employed as an important element in the composition, and again the boundaries of the drawing should be judged intuitively.

Landscapes which are delightful to behold are not always suitable subjects for drawing. It is sometimes difficult to interpret what we see in graphic terms, and when we discover a beautiful place, the act of drawing sometimes becomes more important than the end result. The eye runs along the contours of distant hills, or settles on a tree or hedgerow.

→ page 118

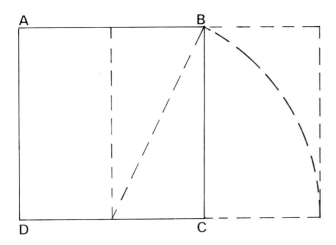

Golden Section
Rectangle divided by the Golden
Section; ABCD = A square.

Chalkland field/Pencil and gouache
The formal geometry of fields bounded
by low flint walls are a feature of
southern landscapes in England

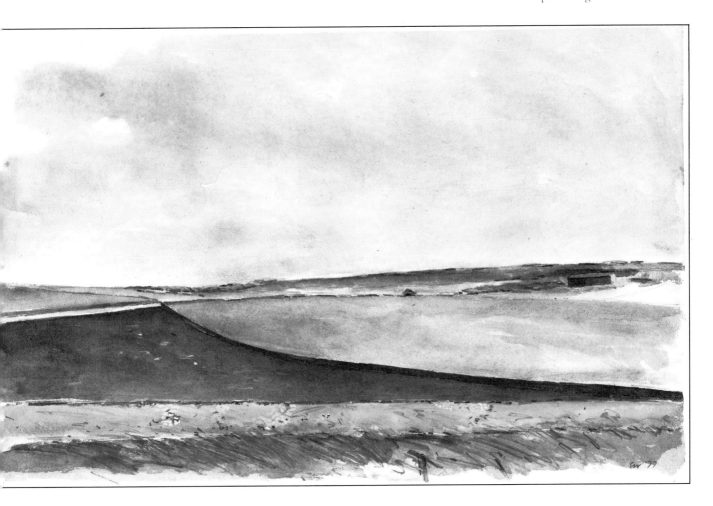

DRAWING: LANDSCAPE AND TOWNSCAPE

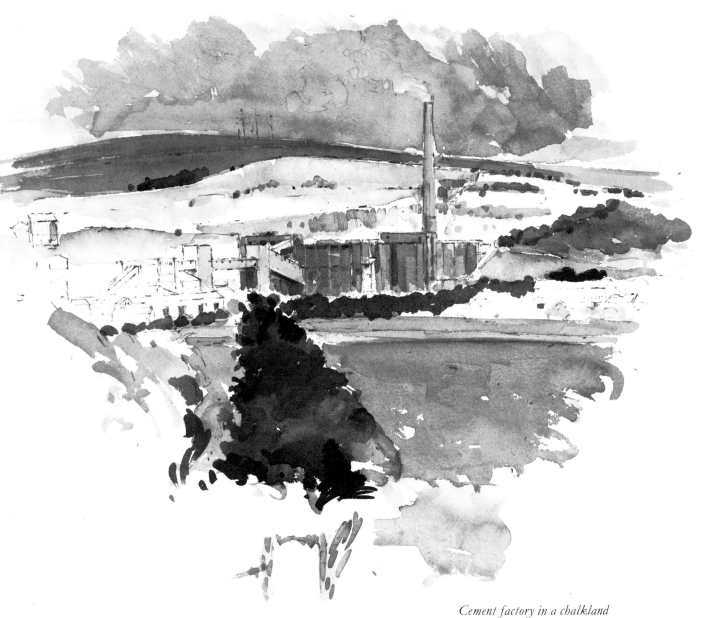

Cement factory in a chalkland landscape/Pencil and watercolour
The vertical structures of the factory buildings provide useful contrasts compositionally, to the predominantly horizontal shapes of the landscape

OPPOSITE:

Two sketchbook studies/Pencil and pen and wash
These intimate studies are beautifully composed, and drawn with great sensitivity
DICK LEE

Coalbrookdale, Shropshire/Pencil and watercolour

We plot this progression with a series of pencil marks on paper and, in describing what we see, it is as if we have walked through the landscape touching every surface. Berenson thought that the quality of fine draughtsmanship depended on this kind of tactile sensation.

Materials for working outside

The selection of materials for working outside is very much a matter of personal choice. No one should be unduly concerned what kind of brush or pencil the artist has used to produce a particular drawing. There are a number of handsomely produced books devoted to technique, in which the range of tools that an artist might utilise are laid out complete with instructions on how to achieve special effects. Alternatively, a painting or drawing that is well known might be reproduced with instructions on how to imitate that artist's method. What one is being offered in my view, is not so much the means of discovery, but ways of escape. There is a tendency to seek novelty through various techniques, rather than to use them in the service of an idea. The pressure to produce something that can be exhibited, or is saleable, often creates anxiety. But if the artist's occupation merely represented a means of earning a living, he would produce nothing. Unless one has the ambition to be a good draughtsman there is no point in going on.

There are a few commonsense observations that I can make from my own experience of working outside. Firstly, it is useful to remember that equipment should be kept to a minimum so that everything can be carried in a shoulder bag. In searching for the right vantage point from which to draw, it is sometimes necessary to climb up and down hills or steep flights of steps. It might also be necessary to walk considerable distances under conditions of intense heat.

I like to work with a variety of different papers – Saunders, Arches Aquarelle, Bockingford – for both pencil and watercolour. Additionally, I like to use a toned paper to avoid the glare that one gets with white paper under direct sunlight. There are some English handmade paper companies who sell packs of mixed toned paper as 'seconds'. Sheets of paper of various sizes I carry sandwiched between two stout pieces of cardboard held together with foldback metal clips. The card makes a substantial drawing base and the clips are used to hold the paper in place.

I prefer soft lead pencils from 2B–6B and occasionally use an old fountain pen which has a broad nib and flows easily. I always use watercolours of good quality and sable hair brushes – less expensive products are really a false economy. Almost any pot with a secure top will do for water, though French pâté jars have a hinged top that is very watertight. There are a number of very small folding stools of the type used by fishermen which are most useful and easy to carry.

Gouache might be more suitable for townscape subjects or certain types of landscape. Egg-tempera can also be bought in tubes and produces rich colours which have great permanency. Tempera needs a more solid support than either watercolour or gouache. I usually use board coated with gesso.

For most subjects I begin drawing in pencil. I then add washes of watercolour, building up the tonality by overlaying washes gradually. If on the other hand I am dealing with a pure landscape subject, I might begin working right away with a brush using a mid-tone. The balance between the drawing and subsequent washes of watercolour is critical. To produce a complete drawing in pencil, and then to overlay washes of watercolour, would simply be to produce a tinted drawing. Each constituent part must work with the other, so that parts of the drawing in pencil or brush are left exposed, and washes of colour work in such a way that they are part of the drawing. It's a tall order, but nothing is more beautiful than when drawing and colour work together – as in the watercolours of Cézanne for example. There is a need to be sometimes tentative, sometimes bold – to be prepared to gain or lose everything.

→ page 122

OVERLEAF:

Burnt Field/Watercolour

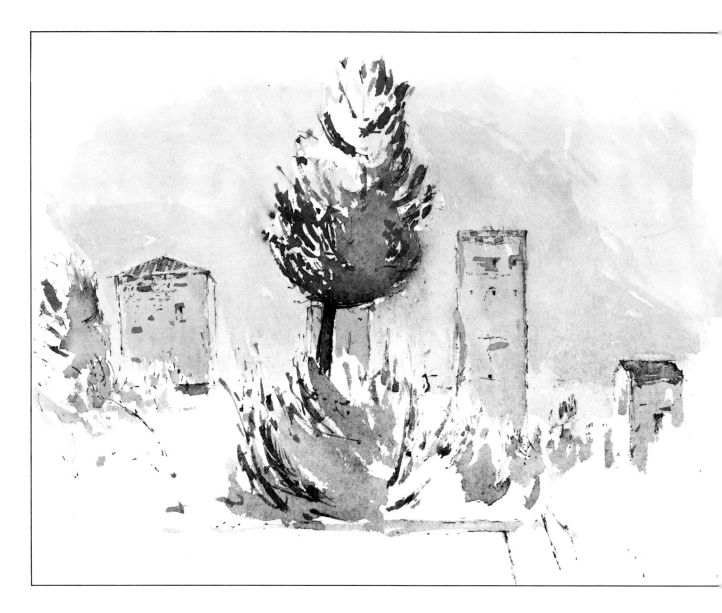

San Gimignano/Pencil and watercolour

If I am drawing a subject such as the towers of San Gimignano seen from outside the city walls (*see page 100*), I would first consider how much time I had before the light changed radically. I might for instance, decide to do two drawings—a morning view when the sun pounds the face of the stonework producing sharp contrasts, and an afternoon view when the towers are in shadow and the tones more muted. All the preliminary organisation and construction is sorted out in pencil, relating detail to detail the unifying features of the composition. The drawing progresses, checking one line against another; if the first marks are unsound, subsequent marks will soon make the drawing go adrift.

My sense of measurement and proportion comes from close observation, rather than from any particular method or calculation. The width of a building for example, might be determined by the way I judge visually the spaces between windows, or the height of a building might be related to the height of an adjacent tree. I like to reach that point in a drawing where things begin to relate to each other, and a kind of unity and rhythm is established.

When the main body of the drawing is completed I would then begin to work in colour. I work generally from light to dark, using the

San Gimignano/Pencil and watercolour

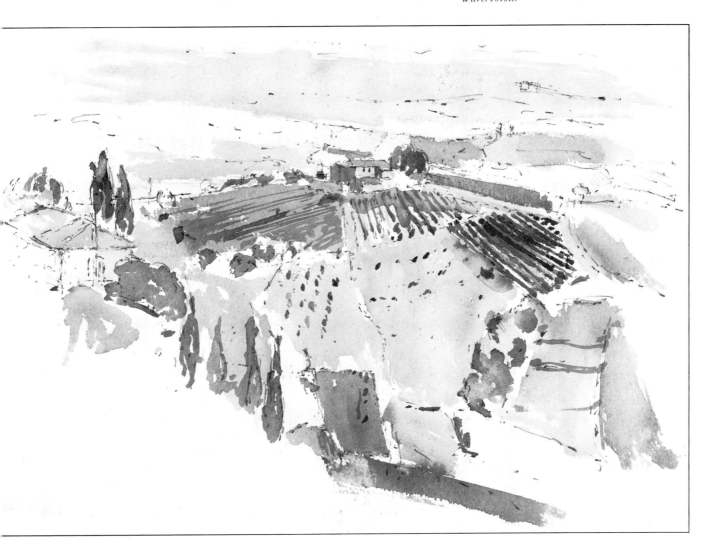

purest colours first since water soon becomes dirty from the constant cleansing of the brushes. I take great care in mixing colour – a cerulean blue might be mixed with just a hint of rose-madder for a sky, or olive green might be mixed with chrome yellow and lamp black, with no blue at all. Washes of colour are carried through to all those parts of the drawing where it can both stand alone, and also influence other colours to be overlaid. So that the blue wash used for a sky for instance, might also underpin the shadow of a building or of foliage.

Watercolour has the advantage of drying rapidly, especially in a hot dry climate, therefore washes can be overlaid quite quickly, thus retaining the value of transparency. Too many washes laid wet on wet simply cause the drawing to become muddy. As the work develops I become bolder and begin to cancel out parts of the drawing made earlier, and to re-state things in another colour. There are gains and losses until one reaches that point when to continue working would add nothing more to the statement one is trying to make. It is sometimes difficult to recognise exactly when that point has been reached, and inevitably the drawing sometimes becomes overworked – it is the kind of decision that becomes easier to make with experience.

It is not always possible to evaluate what one has achieved immediately; it may take a day or so to assess whether or not one has produced a drawing which one feels is authentic and convincing. For most of the time I am dissatisfied not so much with myself, but with the inadequacy of my talent. Perhaps the knowledge that I have not succeeded in producing the drawing I wanted is the essential stimulus that makes me want to go on.

Finally, to end as I began, I would like to encourage anyone who draws and paints to continually work from direct observation in order to develop a personal view. The general belief is that the artist must first find his subject, but more often than not if he is patient the subject will find the artist – and he must then be able to deal with it in his *own* terms.

OPPOSITE:

Olive tree/Etching on Zinc

DRAWING: LANDSCAPE AND TOWNSCAPE

The Artists

Bonnard, Pierre
Born Fontenay-aux-Roses, France, 1867.
Studied law in Paris 1888–1890; during same period enrolled at the Academie Julian and the Ecole des Beaux-Arts where he met Vuillard and Roussel. Poster for France-Champagne, 1891, attracted attention of Toulouse Lautrec. Travelled in Spain with Vuillard, 1905. First one-man show at Bernheim-Jeune, 1906. In Italy, Algeria and Tunisia, 1908; first visit to the South of France, 1910. Lived in Vernon, 1912. Bought villa at Le Cannet, 1925. Short visit to the USA, 1926. Retired to Le Cannet, 1939. Died at Le Cannet 1947

Lithograph on page 8.

Cezanne, Paul
Born Aix-en-Provence, France, 1839.
Studied at the Bourbon College, 1852, where he met Zola and Baille; at the Academy of Drawing in Aix, 1858; at the University of Aix (studying law) 1859–61. Joined Zola in Paris, 1862, where he remained with intermittent visits to Aix until 1970. (Rejected by the Salon, 1866). Lived at L'Estaque, 1870; worked with Pissarro near Pontoise. Exhibited three paintings in the 1st Impressionist Exhibition, 1874; sixteen in the 3rd in 1877. Working at Zola's house at Melun, also at Pontoise, 1879–81; working visit to L'Estaque with Renoir, 1882. Visited Monet at Giverney in 1894. Exhibition of 150 paintings by Cezanne, 1895, organised by Vollard on the advice of Pissarro. Settled in Aix, 1896, where he continued to work until his death in 1906.

Drawing on page 15

Chamberlain, Christopher
Born 1918.
Studied at Clapham School of Art 1934–7; at the Royal College of Art 1938–9 and 1946–7.
RCA degree 1947, followed by part-time teaching at Camberwell School of Art and at Bromley. Full-time teaching began at Camberwell, 1972–84, where he was Acting Head of Fine Art (1981–2) and principal lecturer (1982–4); also visiting lecturer and external assessor to the Sheffield, Colchester, Byham Shaw, Ravensbourne and Bournemouth Colleges of Art. One-man exhibition held at the Trafford Gallery, 1954. His work appears in many art galleries and private collections in the UK and overseas, also in book illustration.
Died 1984.

Drawings on pages 20, 23, 81, 82, 83, 84, 86, 87

Cooke, Randall
Born 1946
Studied at Camberwell School of Art, 1966–69; Chelsea School of Art (post-graduate) 1969–70.

Exhibited at the Whitechapel 1979; 'Art For Society' Tom Allen Centre 1986; and at Woodlands, Greenwich, 1986

Drawing on page 62

Davis, Kate
Born Cheshire, 1954.
Studied illustration at Brighton Polytechnic where she was tutored by Gerald Woods. Gained a place on the post-graduate course at the Royal Academy Schools, and now combines teaching with drawing and painting from direct observation.

Drawings on pages 26, 27.

Eyton, Anthony, ARA
Born London, 1923.
Studied at Camberwell School of Art 1947–50. Received Abbey Major Scholarship to work in Italy, 1951–2. First one-man exhibition at St George's Gallery 1955. One-man exhibition at Galerie de Scène, 1957. Teaching at Camberwell School of Art 1957–. One-man exhibition at New Art Centre, 1959, 1961 and 1968. Teaching at Royal Academy Schools 1965–. Exhibited in 'Survey '66' at Hampstead Art Centre, 1966. Exhibited in 'Figurative Painters' at Hampstead Art Centre, 1967. Head of Painting Department at St Lawrence College, Kingston, Ontario, 1969. Exhibited in John Moores Exhibition, Liverpool (prizewinner), 1972. One-man exhibition at New Grafton Gallery, 1973. Awarded Grocers Company Fellowship to work in Italy for six months, 1974. One-man exhibition at Darby Gallery, 1975. Exhibited in 2nd British International Drawing Biennale (1st prize) 'Drawings of People' at Serpentine Gallery, 1975. Elected Associate of Royal Academy 1976. Exhibited in 'British Painting 1952–1977' at Royal Academy, 1977. One-man exhibition at Browse & Darby, 1978 and 1985.

Drawings on pages 50, 51, 52, 53, 54, 55

Giacometti, Alberto
Born Borgonovo, Switzerland, 1901.
Son of post-impressionist painter Giovanni Giacometti, Alberto began drawing 1910, producing first painting three years later. Enrolled at the Ecole des Arts et Metiers in Geneva, 1919. Studied at the Academy of the Grande Chaumier under Antoine Bourdelle, 1922–25.
Exhibited sculpture in the Salon des Tuileries, 1925. Exhibited with the Surrealists 1928. Exhibited in New York 'Art of this Century', 1945. In 1946 began to concentrate on drawing from the model, and continued up to his death in 1966.
Retrospective exhibitions have been held in London, New York and Venice.

Awarded an honorary doctorate by the University of Berne in 1965.

Drawing on page 13.

de Grey, Roger, FRA
Born Buckinghamshire, 1918.
Studied at Chelsea School of Art 1937–9 and 1946–7.
Taught in Fine Art Department at University of Newcastle-upon-Tyne 1947–51. Master of Painting at King's College, University of Newcastle-upon-Tyne 1951–3. Senior Tutor (and later Reader) in Painting at Royal College of Art 1953–73. Elected Honorary Associate of Royal College of Art 1959. Elected Associate of Royal Academy 1964. One-man exhibition at Leicester Galleries, 1967. Elected Royal Academician 1969. Principal of City and Guilds of London Art School 1973–. Treasurer of Royal Academy 1976. Prizewinner in Summer Exhibition at Royal Academy 1979. President of Royal Academy 1986.

Drawing on page 103.

Inlander, Henry
Born Vienna, 1925.
Studied at St Martins, at Camberwell and at the Slade Schools of Art, 1935–52. Rome Scholar, 1952.
Art advisor at the British School, Rome, 1955–56. One-man exhibition Leicester Galleries, 1956; 'The Religious Theme' Tate Gallery, 1958. Taught drawing and painting at Camberwell School of Art until his death in 1984.

Drawings on pages 63, 74–5, 88, 102.

Jarvis, Roland
Born in France, 1926.
After gaining a BSc in engineering, studied art first at Guildford and then at Chelsea School of Art, where he was influenced by Ceri Richards. Continued studies in Paris, at the Grande Chaumier (painting) and Atelier 17 (Etching).
Has taught drawing and graphic art at Watford and Kingston Colleges of Art, and is at present Drawing tutor at Brighton Polytechnic. Lives and works in a converted Methodist Chapel in Hastings. Apart from drawing and painting spends much of the winter months making clocks. Awarded a South East Arts Award in 1980.

Drawings on pages 32, 33, 45, 72–3, 76.

Lee, Dick
Born Southern Rhodesia, 1923.
Studied at Camberwell School of Art 1947–50. Awarded Abbey Major Scholarship, 1951. Taught at Maidstone College of Art 1956–7; at Camberwell School of Art 1950–82.
One-man exhibitions include Galerie de

Seine, 1958; New Grafton Gallery 1970/72/74/78/82/85; 'Notices', Camden Arts Centre 1978; Gillian Jason Gallery 1983; Surrey University 1983.

Drawings on page 116.

Pemberton, Christopher
Born 1923.
Kings Scholar at Eton. Read history, 1946–8, at Christ Church, Oxford. Studied art at Camberwell 1949–50. Taught at various schools including Bryanston and Shrewsbury. From 1958 taught drawing and painting at Camberwell. Has had a number of one-man exhibitions, including one at Blackheath of Normandy landscapes. Now living in Suffolk, finding drawing hard and painting harder.

Drawings on pages 28, 78.

Rembrandt, Harmensz van Rijn
Born Leyden, 1606.
Entered Leyden University, 1620. Became pupil of painter van Swannenburgh. Established as an independent painter in 1625. First large commission – 'The Anatomy Lecture of Dr Nicholas Tulp' – painted 1632. First large landscape painted 1636. Declared bankrupt 1656. All possessions sold. Died 1669.

Drawings on pages 12, 16.

Salmon, Tabitha
Born Kent, 1955.
Studied at Croydon College of Art and Brighton Polytechnic where she was tutored by Gerald Woods.
Following teacher training at Goldsmiths' College of Art, she has worked as a part-time lecturer in various colleges including Canterbury, Southampton and Brighton. Commissions include a series of large-scale watercolours for St Thomas's Hospital, London. An exhibition of drawings made at Greenham Common was sponsored by the Greater London Council.

Drawings on pages 56–57.

Symons, Patrick
Born Kent, 1925.
Studied at Camberwell School of Art with Euston Road School painters and John Dodgson, 1948–50.
Taught at Camberwell School of Art and St Albans School of Art, 1953–9. Teaching at Chelsea School of Art, 1959–.
One-man exhibition at New Art Centre, 1960. Exhibiting at Summer Exhibitions at Royal Academy, 1969–. Exhibited in 'British Painting '74' at Hayward Gallery, and in John Moores Exhibition,

Liverpool, 1974. One-man exhibition at William Darby Gallery, also exhibited in 'Drawings of People' at Serpentine Gallery, and travelling, 1975–6. Exhibited in 'Hayward Annual' at Hayward Gallery, 1979.

Drawings on pages 58, 59, 60, 61.

Ward, John, CBE, RA
Born Hereford, 1917.
Studied at Hereford School of Art, 1933–6; at Royal College of Art (received travelling scholarship and drawing prize), 1936–9.
Taught part-time at Wimbledon School of Art, and worked part-time for *Vogue* magazine, 1948–52. Working as portrait painter and book illustrator (H E Bates' Autobiography, Richard Church's *Little Kingdom*, etc), 1952–. Elected Associate of Royal Academy, 1956. Illustrated *Cider with Rosie* by Laurie Lee (Chatto & Windus), 1959. One-man exhibition at Maas Gallery, 1964/67/71/72/73/74/76/78. Elected Royal Academician, 1965.

Drawings on pages 70, 107

Wilson, Susan
Born 1961.
Studied at Camberwell School of Art, 1979–82; at Royal Academy Schools, 1982–85.
Fine Art Fellow, Gloucester College of Art, 1985–86.

Drawings on pages 66, 69, 84.

Woods, Gerald
Born Shropshire, 1942.
Studied at Shrewsbury School of Art 1956–60; at Camberwell School of Art 1960–2. Short Scholarship to Italy, 1962.
Taught drawing and graphic art at various colleges including Camberwell, Watford and Brighton 1963–. Publications include, with Philip Thompson, *Art Without Boundaries* (Thames & Hudson 1972), and with John Williams, *Creative Landscape Photography* (Batsford 1980). Established a private press in 1977 producing hand-printed editions of contemporary poets including C H Sissons, Elizabeth Jennings and Robert Wells. Books selected for the Victoria & Albert Museum exhibition 'The Open and Closed Book', 1981. One-man exhibitions at the Holford Gallery, and in West Germany and Switzerland.

Drawings on pages 2, 19, 24–5, 29, 30, 31, 34–5, 36, 37, 38–9, 40–1, 43, 44, 46–7, 48, 64, 65, 68, 71, 77, 91, 92–3, 94, 95, 96, 97, 98, 99, 100, 104–5, 109, 110, 111, 112, 113, 115, 117, 118, 120–21, 122, 123, 125.

Selected Bibliography

Bouvet, Francis
Bonnard – The Complete Graphic Work
Thames & Hudson, London, 1981

Chappuis, Adrien
The Drawings of Paul Cezanne
Thames & Hudson, London, 1973

Clark, Sir Kenneth
The Nude
Penguin, London, 1956

Guerin, Marcel (Edited by)
Degas Letters
Bruno Cassirer, Oxford, 1947

Lord, James
A Giacometti Portrait
Farrar Straus Giroux, New York, 1980

Medley, Robert
Drawn From The Life
Faber & Faber, London, 1983

Meili, Jean-Guichard
Matisse
Thames & Hudson, London, 1967

Rewald, John
Paul Cezanne – The Watercolours
Thames & Hudson, London, 1983

Ryle, Gilbert
The Concept of Mind
Penguin, London, 1963

Sausmarez, Maurice de (Edited by)
Ben Nicholson
Studio International, London, 1969

Sitwell, Osbert (Edited by)
*A Free House – The Writings of
Walter Richard Sickert*
Macmillan, London, 1947

Stewart, Jean (Edited by)
*Eugène Delacroix Selected Letters
1815–1863*
Eyre & Spottiswoode, London, 1971

Terrasse, Antoine
Pierre Bonnard
Gallimard, France, 1967

Vernon, M D
The Psychology of Perception
Penguin, London, 1962

Vollard, Ambroise
Degas
Crown Publishers, New York, 1937